DÜRER TO DIEBENKORN
Recent Acquisitions of Art on Paper

DÜRER TO DIEBENKORN:

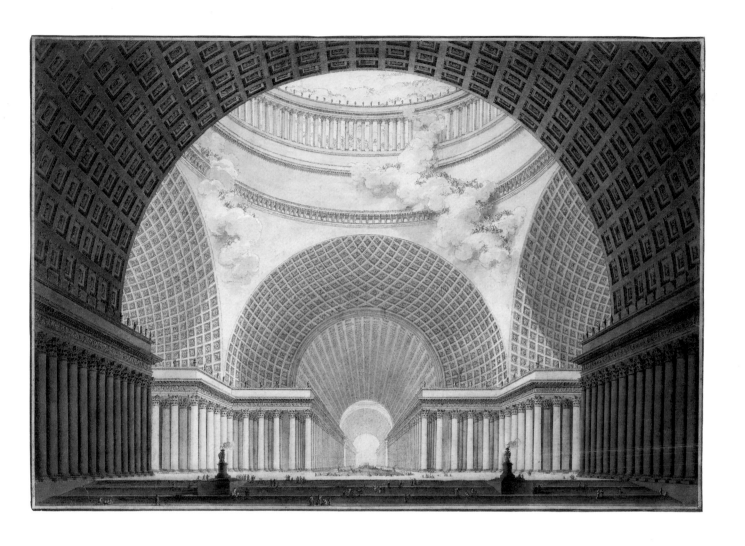

Recent Acquisitions of Art on Paper

ANDREW ROBISON

with JUDITH BRODIE

RUTH E. FINE

MARGARET MORGAN GRASSELLI

SARAH GREENOUGH

National Gallery of Art
Washington

DÜRER TO DIEBENKORN
Recent Acquisitions of Art on Paper
was organized by and shown at the
National Gallery of Art, Washington.

Exhibition dates: 10 May–7 September 1992

Produced by the editors office, National Gallery of Art
Editor-in-Chief, Frances P. Smyth
Edited by Jane Sweeney

Designed by Susan Lehmann
Typeset in Meridien by VIP Systems, Inc., Alexandria,
Virginia
Printed on LOE Dull by Virginia Lithograph, Arlington

Library of Congress Cataloging-in-Publication Data
Dürer to Diebenkorn: recent acquisitions of art on paper
Andrew Robison with Judith Brodie . . . [et al.].
p. cm.
Exhibition catalog.
ISBN 0-89468-182-6
1. Art, Modern—Exhibitions. 2. National Gallery of Art
(U.S.)—Exhibitions. I. Robison, Andrew. II. Brodie,
Judith. III. National Gallery of Art (U.S.)
N6350.D87 1992
760'.074'753—dc20 92-12706
 CIP

Note to the Reader
Measurements are given in millimeters, height
preceding width, followed by inches in parenthe-
ses. Measurements for drawings and contempo-
rary prints refer to sheet size. Other prints are
measured at the outermost points of the image.

A checklist can be found at the end of each essay.

cover: cat. 9. Hans Hoffmann, *Red Squirrel*

frontispiece: cat. 42. Etienne-Louis Boullée, *Perspective
View of the Interior of a Metropolitan Church*

back cover: cat. 4. Albrecht Dürer, *The Triumphal Arch
of Maximilian*

Photo Credits
All photography by the department of photo services,
National Gallery of Art. Walker Evans photograph © The
Estate of Walker Evans.

Contents

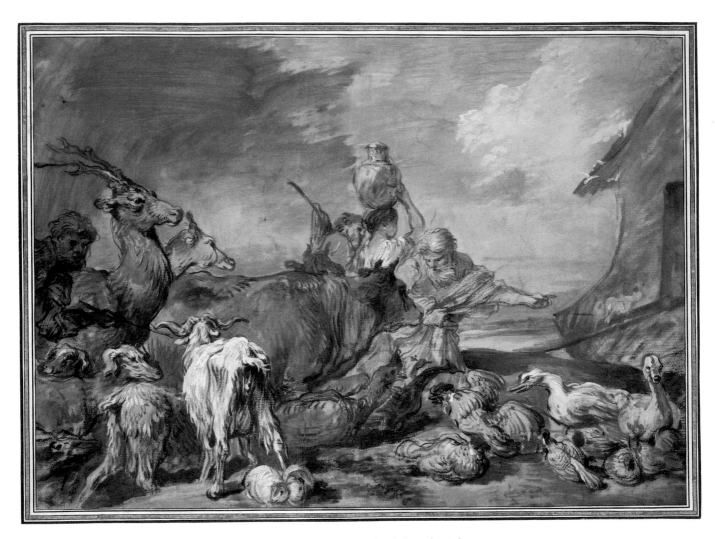

cat. 22. Giovanni Benedetto Castiglione, *Noah Leading the Animals into the Ark*

Foreword

The National Gallery's collections are its reason for being. The year leading up to the present exhibition has been one especially remarkable for additions made to those collections both by gift and by purchase. The Gallery's fiftieth-anniversary year, which was celebrated on the Gallery's actual golden anniversary in March 1991 by the opening of the exhibition *Art for the Nation,* was only the beginning of a remarkable series of gifts and purchases that have augmented and embellished the permanent collection in many ways. Since then additional anniversary gifts were generously offered by many donors and important purchases have been made. As they have been received, major sculptures and paintings have been added to the main galleries. For example, the splendid Houdon plaster of *George Washington* given by Robert L. McNeil, Jr.; the extraordinary Rodin plaster for *The Age of Bronze* donated by Iris and B. Gerald Cantor; and the important bronze *Scheherazade* by Anthony Caro, the gift of Guido Goldman, are all on view. Fine paintings newly given and on exhibit include Teniers' *Peasants in a Tavern* donated by Mr. and Mrs. John Ely Pflieger, Copley's oil sketch for *The Copley Family* from Richard York, and Cropsey's *Warwick Castle* given by Mr. and Mrs. Norman Hirschl. New gifts of contemporary paintings—Noland's 1970 *Dawn's Road* from Irving Blum and two works by Alice Neel from Arthur Bullowa—are being put in place for the public to see. Further gifts of paintings and sculpture will be on long-term display as they are received and prepared for installation.

Some of the areas of the collection that received the greatest enrichment in 1991, however, are just those that cannot be placed on permanent display: works of art on paper. As a result of extraordinary donations and through rare opportunities to purchase, many important works as well as whole collections have made major and fundamental additions to the nation's holdings. To continue our celebrations of the permanent collection, *Dürer to Diebenkorn* thus shows a sample of new works of art on paper in the only way they can be installed, as a temporary exhibition, to indicate the many different aspects in which these collections have been enriched and to thank those responsible for their acquisition.

We wish to acknowledge, in addition to the generosity of our donors, the teamwork at the National Gallery in the preparation of this exhibition as well as the individual efforts of Andrew Robison and his talented colleagues Ruth E. Fine, Margaret Morgan Grasselli, Sarah Greenough, and Judith Brodie who composed the checklists. Grace under the pressure of a tight schedule was demonstrated by many departments: Gaillard Ravenel, Mark Leithauser, and Gordon Anson, heads of installation and design, with John Olson; D. Dodge Thompson, Ann B. Robertson, and Deborah L. Miller of the exhibitions department; Mary E. Suzor and Lauren Cluverius of the registrars office; Frances P. Smyth and Jane Sweeney of the editors office; Shelley Fletcher and Judy Walsh of the paper conservation department; Hugh Phibbs and David Shen, who did the matting and framing;

Dean Beasom of the photo lab; and Genevra Higginson and her staff, who elegantly arranged the opening festivities. Susan Lehmann designed the catalogue.

And as always our greatest thanks go to the donors who made these acquisitions through gift or purchase possible. To them we owe deep gratitude for their outstanding and continuing contributions to the work of the National Gallery.

J. Carter Brown
Director

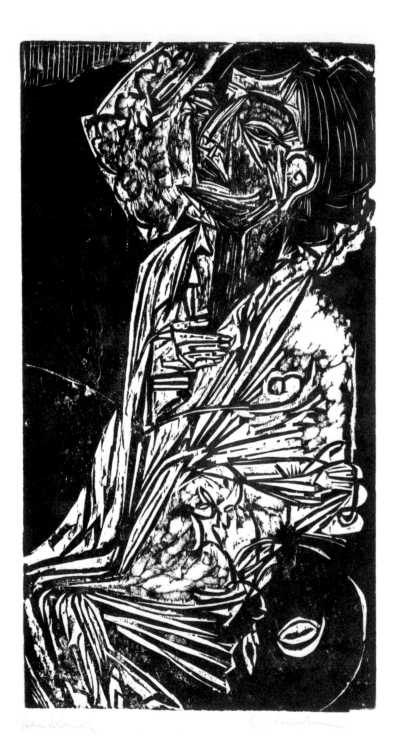

cat. 69. Ernst Ludwig Kirchner, *The Wife of Professor Goldstein*

Introduction

The genesis of this exhibition was the remarkable outpouring of gifts that came to the National Gallery after the March 1991 opening of *Art for the Nation,* the exhibition celebrating the Gallery's golden anniversary. Friends of the Gallery continued to come forward with major donations during the anniversary year that followed. In 1991 we were also extremely fortunate to make a number of important acquisitions by purchase from our endowment funds as well as by a combination of purchase and gift. More than one thousand additions came to the permanent collection of graphic art: drawings, prints, photographs, and illustrated books. A small but representative selection from this array is the subject of *Dürer to Diebenkorn: Recent Acquisitions of Art on Paper.*

Our field of choice was broad in the number of works but narrow in the time of their acquisition: only those works of graphic art that joined the collection during the past year were eligible for consideration. We excluded the many important fiftieth-anniversary acquisitions shown last March and the major collections acquired last year that have already been represented in recent exhibitions *(Paul Strand, Walker Evans, Graphicstudio).* Other collections among these recent acquisitions will be exhibited in the next few years (Woodner, O'Neal, Marcy, Avery, Vogel, Gemini, Crown Point Press), so included here are only a few samples to hint at the extraordinary displays to come. We also wanted to surprise as well as delight. For example, extensive publicity surrounded the Gallery's acquisition of the Woodner Family Collec-

tion, including two of the greatest drawings in America, the Cellini *Satyr* and the page of Florentine drawings from Vasari's *Libro di Disegno.* Rather than exhibiting these now, we have saved them for the Woodner exhibition and include here several master works new to the Woodner Collection since it was seen at the Gallery in 1983.

Even with such narrow limits for our choices, this exhibition of recent acquisitions illustrates very well our longer-term goals. We make every effort to build our early Italian prints and drawings toward the superlative level of the Gallery's paintings and sculpture; at the same time we continue to add strength to the collection of early German prints and drawings that is already the nation's finest. The same balance appears throughout. Northern mannerism, Italian and German baroque, the neglected but exquisite beauty of old master portraits, illustrated books, Spanish drawings, British drawings and watercolors, photographs, and contemporary art are relatively new areas on which we have concentrated in the past two decades, and they all find emphasis here. At the same time this exhibition shows our attempts to improve the holdings in graphic art for which the Gallery has long been well known: Dürer, Rembrandt, eighteenth-century French, Blake and his circle, Daumier, German expressionists, and classic twentieth-century French. One of our newest areas of focus is shown here for the first time: German romanticism, whose augmentation we hope will eventually enable the Gallery to complete its panoply of

the best in German graphic art from the twelfth century to the present.

Like virtually all American museums without public funds for acquisition, the National Gallery takes the character of its collections from the generosity of its donors of works of art and of funds with which to purchase. The curatorial staff may pursue special areas of interest in research and among collectors, may search the world for unusual opportunities to purchase, may try its best to continue the interests of our past donors as well as to round out the Gallery's collections with fine but overlooked artists and works. Ultimately, however, it is the agreement, the support, and the magnanimity of our donors that enable the collection to grow in strength. To all those generous friends, so wonderfully helpful over the years, we owe our deepest thanks for the beauties of this and all the exhibitions of our graphic art.

Andrew Robison
Andrew W. Mellon Senior Curator

cat. 2. Albrecht Dürer, *Male Nude* (recto) and *Male Nude with a Lion* (verso)

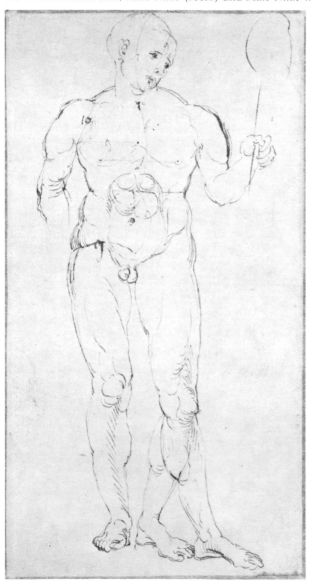 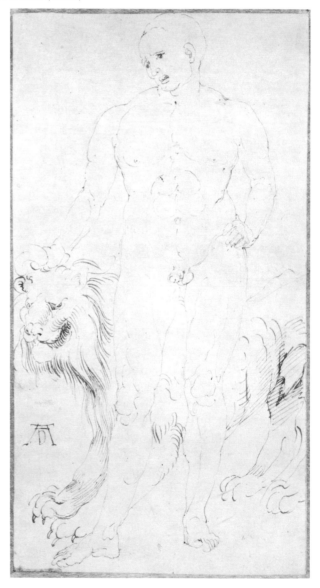

The Renaissance and the Baroque

ANDREW ROBISON

BY FAR THE MOST IMPORTANT addition in many years to the National Gallery's collection of old master drawings was the acquisition of the core of the Woodner Family Collection. This is one of the highest points in the Gallery's two-decade effort to build a drawings collection of national distinction and is especially crucial for that period most beloved by Ian Woodner, the Renaissance. From the Woodner Collection, Albrecht Dürer's *Male Nude* (cat. 2) represents one essential theme of the period: the attempt to represent the human figure in a perfect proportion—and more generally to grasp and understand the natural world—in mathematical terms. This is the Gallery's seventh Dürer drawing but the earliest nude figure, and in fact it appears to be Dürer's earliest surviving proportion drawing of a male nude. One clearly sees the artist's effort to locate the principal bodily points and define their numerical ratios in the head and torso; Dürer's natural facility is conveyed even better by his free treatment of the hand and legs and by the variations in the traced verso with its attendant lion.

A second central theme of the Renaissance was portraiture, an art emphasized among Augsburg draftsmen, especially those influenced by Hans Holbein the Elder. Thus Holbein's intensely beautiful *Portrait of a Woman* (cat. 3, see page 20) is a precious addition to the Gallery's early German drawings for its historical importance as well as its quality, and is, as far as I know, the first drawing by Holbein the Elder in any American public collection.

Besides the numerous extraordinary Renaissance works from the Woodner Collection, we also celebrated the acquisition of an early Italian drawing the Gallery has sought for two decades: Vittore Carpaccio's *Sacra Conversazione* (cat. 1), an extremely fine example of the Venetian artist's rare pen compositions. With disarming directness in his strokes Carpaccio created a complex but summary arrangement of forms. It is a work to be viewed slowly and quietly. The peaceful stillness of this outdoor scene and the interlocking rhythms of the figures filling the space with their elegant gestures give this drawing the enchantment of lyrical poetry and relate it directly to some of the best qualities of contemporary Venetian painting.

Equally haunting, though in a strikingly different way, is the troubled mood of barely contained energy in Andrea del Sarto's *Head of Saint John the Baptist* (cat. 5). Although much repaired, this drawing still forcefully conveys the artist's strength of handling and distinctive use of light and shadow to enhance the psychological intensity expressed in the turbulent hair, parted lips, and distant gaze of many of his youthful heads.

The most important early print among the Gallery's 1991 acquisitions is an extremely fine early impression of *The Triumph of the Senators*, c. 1495, by Mantegna or a close follower. This reflects a consistent pursuit of the exceedingly rare contemporary impressions of Mantegna prints, and is the fourth acquired by the Gallery in the past sixteen years. However, we did not include *The Senators*

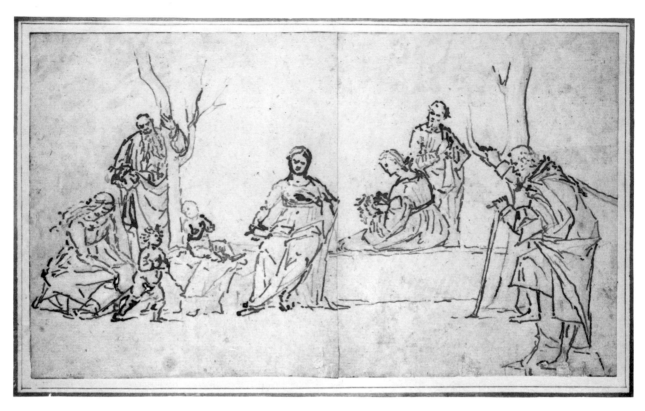

cat. 1. Vittore Carpaccio, *Sacra Conversazione*

in this exhibition in order to lend it instead to colleagues for the current Mantegna exhibition in London and New York.

Although any collection in the world might lack an impression of *The Senators* as early as that one, a young museum such as the National Gallery of Art can be expected to have surprising omissions. This year several were filled by generous donations, including *The Triumphal Arch of Maximilian* given by David Tunick and four French woodcuts given by Hubert and Michèle Prouté and their family. Emperor Maximilian I was a most creative originator of political advertisement through printed pictorial texts. Perhaps his most grandiose project was commissioning Albrecht Dürer to supervise the final design and preparation of a printed arch of triumph, more than eleven feet tall and nine feet broad, containing multiple representations and emblems of Maximilian's genealogy, political history, and personal accomplishments (cat. 4, see back cover). Although this monumen-

tal print was widely distributed at the time of its creation, by the eighteenth century impressions had become exceedingly rare, which led the scholar Adam von Bartsch to reprint the surviving blocks in Vienna. In fact this careful reprint shows the superb quality of the individual woodcuts and enables us for the first time to mount the complete project for view.

The Gallery has had in its collection a number of popular French woodcuts from the late fifteenth and early sixteenth century, but the Prouté gift extends that group for the first time into later periods. For example, the woodcut *Holofernes Interrogating Achior* (cat. 8) seems clearly related to the school of Fontainebleau, otherwise known in printmaking mainly through etchings and engravings. Its large size, allover design with naive perspective, ornamental borders, and even its bold original coloring, here present in superb condition, relate this large print to tapestries as well as to Limoges enameled platters of the period.

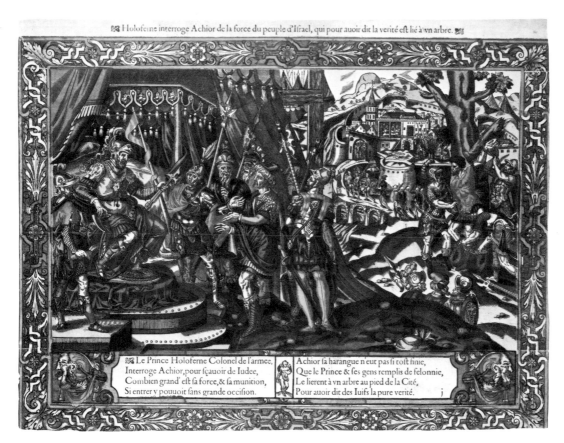

Le Prince Holoferne Colonel de l'armee,
Interroge Achior,pour fçauoir de Iudee,
Combien grand' eft fa force,& fa munition,
Si entrer y pouuoit fans grande occifion.

Achior fa harangue n'eut pas fi toft finie,
Que le Prince & fes gens remplis de felonnie,
Le lierent à vn arbre au pied de la Cité,
Pour auoir dit des Iuifs la pure verité.

cat. 8. French 16th Century, *Holofernes Interrogating Achior*

Purchases of early prints last year, besides the Mantegna, included a fine impression of the large woodcut *Adoration of the Shepherds* (cat. 6, see page 22). Sometimes attributed to the north German Jacob Lucius the Elder, this work is more frequently thought to be too high in quality and too early in style for his work and more likely by a Saxon artist, perhaps of the 1530s, with some relationship to Cranach. Another minor name with a major print is the Veronese artist Giovanni Battista Fontana. His *Mountainous Landscape with the Parable of the Sower* (cat. 7), especially in this strong proof impression, is surely one of the most beautifully realized landscapes in North Italian printmaking of the second half of the sixteenth century.

Among others, two stylistic elements in northern mannerism are an intense regard for naturalistic details and an elevation of sophisticated technique, sometimes in witty imitation or virtuosic challenge of the masters of the past. These themes are brilliantly realized in Hans Hoffmann's *Red Squirrel* (cat. 9, see cover), another gift from the Woodner Collection. The squirrel's soft and fluffy fur is caught with the most delicate brushwork, even tiny highlights in gold, and contrasts marvelously with the springlike tension of his concentrated pose, tension enhanced by the bright taut skin of his flexed knuckles. In and of itself a splendid and completely realized work, the Hoffmann finds a particularly apt context in the Gallery's existing collection of Dürers and other early German drawings, in its recently enlarged group of drawings by artists of several nationalities who like Hoffmann worked at the court of Rudolf II, and especially in one of the Gallery's proudest works from this period and the most famous of all nature drawings from the court of Rudolf, four manuscript volumes by Georg Hoefnagel that bear dates from 1575 to 1582, just contemporary with Hoffmann.

Epitomizing another side of northern manner-

13

cat. 5. Andrea del Sarto, *Head of Saint John the Baptist*

ism is the most recent of the Gallery's drawings by artists who worked at Rudolf's court, the rediscovered *Martyrdom of Saint Sebastian* by Aegidius Sadeler (cat. 15). The rarity of large and compelling drawings by Sadeler makes it hard to understand why some contemporaries thought that he rivaled Goltzius. However, this new discovery, with its unforgettably languorous pose, its soft modeling of warm and caressing light, and its extraordinary conjunction of religious and erotic ecstasy, gives more reason to the high praise of Sadeler's art.

The Gallery's collection of late sixteenth- and seventeenth-century Italian drawings was greatly

cat. 15. Aegidius Sadeler,
*The Martyrdom of Saint
Sebastian*

enriched this year. The series included here begins
and ends with masterworks in color. The earliest
of the seven is Federico Barocci's powerful *Head of
a Bearded Man* (cat. 10, see page 21), another gift
from the Woodner Collection. Its range of blended
colored chalks on dark paper shows Barocci's dis-
tinctive technique. Among such studies this is

especially bold in its free strokes and prominently
lit forehead that projects strongly from the sheet.
In fact, it is Barocci's study for a man straining
forward as he helps carry the dead Christ in one
of the artist's finest paintings, the Senigallia
Entombment of 1579–1582. The counterposed fig-
ure in the composition leaning forward but in the

cat. 7. Giovanni Battista Fontana, *Mountainous Landscape with the Parable of the Sower*

opposite direction, Saint John the Evangelist, was also prepared with a head study by Barocci, this one in oil on paper, which is already in the Gallery's collection. Thus by this acquisition two of the artist's most powerful head studies are reunited after four centuries.

The second extensive collection of drawings received in the Gallery's fiftieth-anniversary year came as a donation from Professor William B. O'Neal. After many years of regular support with individual gifts, Professor O'Neal generously donated and placed on deposit the entire remainder of his collection of nearly three hundred drawings. Though the O'Neal drawings span five centuries, only a few samples from the seventeenth and eighteenth centuries are included in this exhibition, beginning with two impressive works in red chalk. One of the great decorative projects in Rome at the end of the sixteenth century was the painting of the Sala Clementina in the Vatican. The project was shared principally by two brothers from Tuscany, Cherubino and Giovanni Alberti. Cherubino's draped figure (cat. 11) is a fluid and elegantly mannered study for the allegory of *Prudence* in one of the paintings. Not

unusually, this study is traced through to the other side of the paper to reverse its direction, and is also slightly altered in its details. However, in a very sensitive analysis of the stylistic distinctions between the brothers, Kristina Hermann Fiore has shown that the verso figure is actually by Cherubino's brother Giovanni. Thus the O'Neal drawing offers an extraordinary opportunity to see not only the close cooperation between the two, but also the fine distinction between their treatment of the same figure in the same pose, size, and medium. The second red chalk drawing from the O'Neal Collection, Matteo Rosselli's *Standing Man Wearing a Cloak and Hat* (cat. 17, see page 25), is a fine and characteristic study of drapery and light, showing the continuing emphasis in Florentine art on careful studies from the model.

Among purchases of Italian baroque drawings this year, a Leoni and a Della Bella offer particularly charming examples of the artists' work. Ottavio Leoni was the most popular portrait draftsman for Roman society in the early seventeenth century, and his numerous surviving works vary in quality. However, his strikingly beautiful but still unidentified *Young Woman with Braided Hair and a*

16

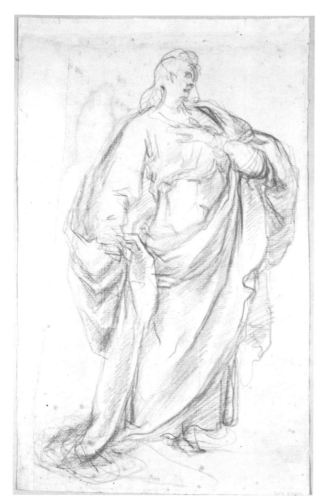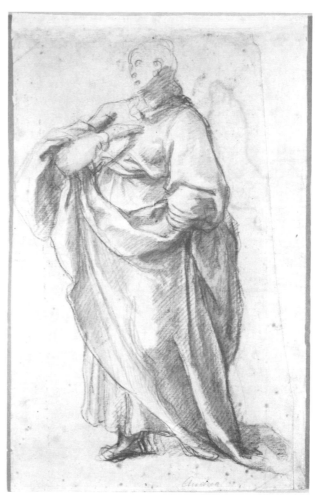

cat. 11. Cherubino Alberti (recto) and Giovanni Alberti (verso), *Prudence*

Veil (cat. 13) shows the intensity, liveliness, and high standard Leoni could achieve. For pure delight and pleasure Stefano Della Bella has been famous among collectors of prints and drawings for three centuries. Those qualities are evident in *Two Men in Masque Costumes* (cat. 18), surely a study for one or another festivity at the Medici court. The sheer fun of one mustachioed dandy dressed as an armored helmet and another dressed as the world is spiritedly conveyed by the artist's delicate calligraphy. While the Leoni and Della Bella join others in the collection, the fine composition drawing of the *Healing of a Possessed Man* by Giovanni Andrea Sirani (cat. 21, see page 25), a gift from the Gallery's chief curator emeritus Sydney J. Freedberg, is the first work in the collection by this artist. Sirani was one of the

heirs and most important followers of Guido Reni, but is perhaps more famous now for being the sympathetic father of three daughters, all of whom he taught to become professional painters: Anna Maria, Barbara, and, the finest of all, Elisabetta.

By far the most stunning Italian baroque drawing recently acquired is the fiftieth-anniversary gift from Gilbert Butler, Giovanni Benedetto Castiglione's *Noah Leading the Animals into the Ark* (cat. 22, see page 6). Like a few other large and colorful brush drawings in oil by the artist, this one combines pictorial finish with bravura draftsmanship. Even the subject is an essential one for Castiglione: whether for more generalized patriarchal journeys or more specific Old Testament stories, the artist delighted again and again in showing a

cat. 18. Stefano Della Bella, *Two Men in Masque Costumes*

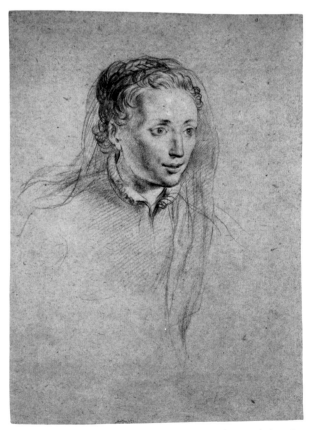

cat. 13. Ottavio Leoni, *Young Woman with Braided Hair and a Veil*

gathering, preferably a massed surge, of various domestic and wild animals. Here the fluid and summary brushwork on the goat, the bull, the old men's heads, and the girl carrying the amphora are striking examples of qualities that would delight and influence eighteenth-century French artists from Boucher to Huet to Fragonard.

The Gallery has in recent years made special efforts to acquire Spanish and German baroque drawings. Thus it is particularly fortunate that two came as gifts in 1991. Hans Jakob Nüscheler's *Elisha Watching Elijah in the Fiery Chariot* (cat. 12, see page 24), a gift from Eva S. Dencker, continues the fluid and open style of sixteenth-century Swiss stained-glass designs into the new century. Furthermore, the O'Neal gift includes a fine example by an artist from Valencia, Francisco Ribalta's *Presentation of the Virgin in the Temple* (cat. 14, see page 23). With nervous calligraphy the artist swiftly created multiple outlines in a complex composition, then brought light and order to the forms with broad areas of wash. The contrast in style with *The Death of Priam* (cat. 24, see page 26) by one of the best seventeenth-century German draftsmen, Michael Lukas Leopold Willmann, is striking. Equally swift with his pen, Willmann nonetheless created expression as well as costume with his initial strokes, and even with wash he never stopped adding to the composition and revising its forms.

In northern baroque prints also the Gallery recently received several fine gifts. While the collection has long been known for its Rembrandt paintings, drawings, and prints, it has never had one of Rembrandt's very rare illustrated books. Thanks to a generous anonymous gift we acquired a fine copy in contemporary Dutch binding of the very first book with a Rembrandt illustration, Elias Herckmans' *Der Zee-Vaert Lof* (Amsterdam, 1634, cat. 16), which also contains seventeen etchings by Willem Basse. In his extended poem, Herckmans, himself a former sailor, dealt with the most notable sea voyages of the world from the beginning of history to his day. Adjusting the image to Herckmans' text and cleverly compressing baroque allegory and narrative into the size of the page, Rembrandt's etching shows the Emperor Augustus declaring peace as the doors of the Temple of Janus are closed and sending forth a merchant vessel guided by a very Dutch Fortune.

18

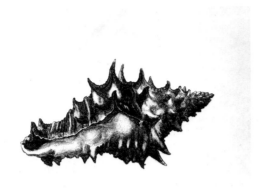

cat. 19. Wenceslaus Hollar, *Shell [Vasum ceramicum]*

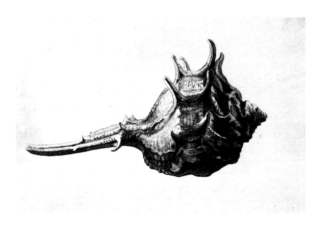

cat. 20. Wenceslaus Hollar, *Shell [Murex brabdaris]*

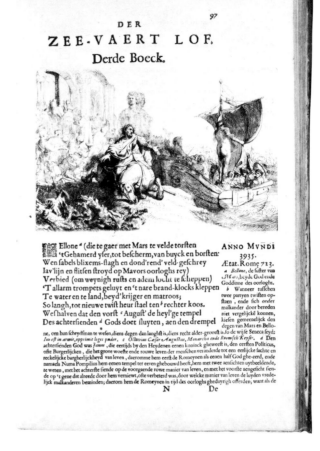

cat. 16. Rembrandt van Rijn, *The Ship of Fortune*

As early as the eighteenth century Wenceslaus Hollar's series of thirty-eight etched seashells was of fabled rarity and great price. Made around 1645, these exquisite renderings of exotic shells show the artist's virtuosity at its finest. Using a wide variety of line, hatching, and stipple, Hollar created an extraordinary variation of tone in which light seems to find and envelop every tiny protuberance and convey every variation in texture of the complicated surfaces: each shell, floating free on a blank background, acquires an intense individuality bordering on the surreal. Gifts of Edward William Carter and Hannah Locke Carter, these rich early impressions of two of Hollar's spikiest shells (cats. 19, 20) clearly show why the rare set had so great an influence

on other artists, provoking even Rembrandt to try his hand at making his only still-life etching, a single shell.

The Gallery has long had an outstanding collection of Robert Nanteuil's refined, sensitive, and lively portrait engravings. In fact its basis is the collection formed by Nanteuil's principal cataloguer, purchased and given en bloc by Lessing J. Rosenwald. As was the case with Rembrandt, however, the Gallery's collection lacked any of Nanteuil's illustrated books. Thanks to the donation of Mr. and Mrs. Pierre Berès, we now have one of the most interesting, the 1656–1657 *Memoires* by Michel de Marolles (cat. 23, see page 26), which contains portraits of Marolles by two of the greatest seventeenth-century French portrait

engravers, Nanteuil and Claude Mellan. There could hardly be a better text for the Gallery's collection than Marolles' memoirs. Perhaps the most extraordinary print collector who ever lived, he amassed over forty years 123,000 prints and drawings of high quality, which were purchased for the king in 1667 by Colbert as the basis of one of the world's greatest collections, now the Bibliothèque Nationale. Undaunted, immediately after the sale to the king Marolles began a second collection that eventually grew to more than 100,000 prints and 10,000 drawings. Sadly, he used no mark or paraph to identify works in his collection; but as the works in his first collection enriched France beyond measure, one expects those from his second eventually helped other collections throughout the world, even that of our National Gallery.

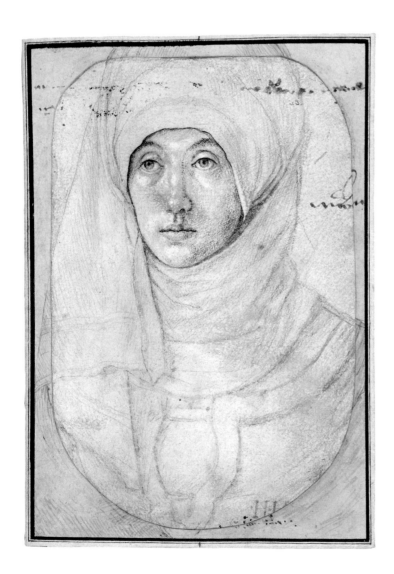

cat. 3. Hans Holbein the Elder,
Portrait of a Woman

20

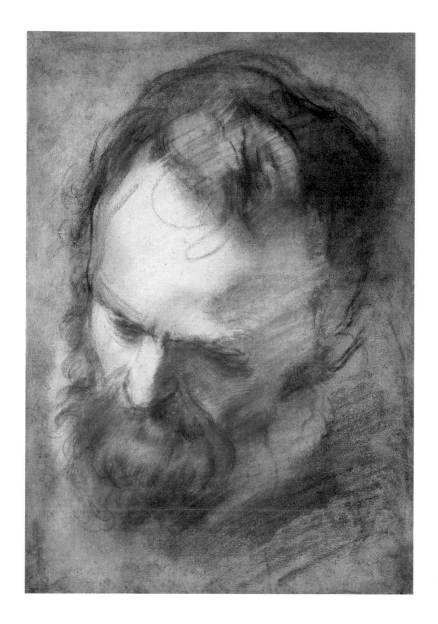

cat. 10. Federico Barocci,
Head of a Bearded Man

1
Vittore Carpaccio
Italian, 1455/1465–1525/1526
Sacra Conversazione, c. 1500
pen and brown ink, 139 x 236 (5 7/16 x 9 5/16)
Patrons' Permanent Fund
See illustration on page 12.

2
Albrecht Dürer
German, 1471–1528
Male Nude (recto)
Male Nude with a Lion (verso), c. 1500
pen and brown ink, 267 x 141 (10 9/16 x 5 9/16)
Woodner Family Collection
See illustrations on page 10.

3
Hans Holbein the Elder
German, 1460/1470–1524
Portrait of a Woman, c. 1510
silverpoint heightened with white and black ink on
white prepared paper, 144 x 103 (5 11/16 x 4 1/16)
Woodner Family Collection

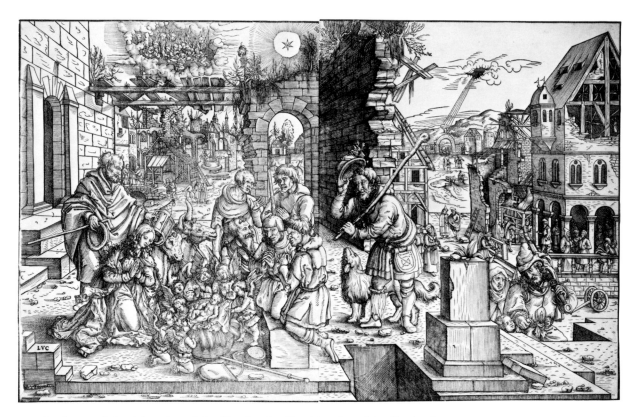

cat. 6. Master of the Adoration of the Shepherds, *The Adoration of the Shepherds*

4
Albrecht Dürer
German, 1471–1528
The Triumphal Arch of Maximilian, 1515 (1799 edition)
42 woodcuts and 2 etchings
3,409 x 2,922 (134 ¼ x 115)
Gift of David Tunick, in Honor of the Fiftieth Anniversary of the National Gallery of Art
See illustration on back cover.

5
Andrea del Sarto
Italian, 1486–1530
Head of Saint John the Baptist, c. 1523
black chalk, 330 x 231 (13 x 9 ¹/₁₆)
Woodner Family Collection
See illustration on page 14.

6
Master of the Adoration of the Shepherds
German, active c. 1520–1540
The Adoration of the Shepherds, probably 1530s
woodcut, 341 x 522 (13 ⁷/₁₆ x 20 ⁹/₁₆)
Ailsa Mellon Bruce Fund

7
Giovanni Battista Fontana
Italian, c. 1524–1587
Mountainous Landscape with the Parable of the Sower, c. 1572–1573
etching, 187 x 300 (7 ³/₈ x 11 ¹³/₁₆)
Ailsa Mellon Bruce Fund
See illustration on page 16.

8
French 16th Century
Holofernes Interrogating Achior, c. 1575
hand-colored woodcut, 385 x 495 (15 ⅛ x 19 ½)
Gift of Hubert and Michèle Prouté and Family in Memory of Jean Adhémar and Paul Prouté and in Honor of the Fiftieth Anniversary of the National Gallery of Art
See illustration on page 13.

9
Hans Hoffmann
German, c. 1530–1591/1592
Red Squirrel, 1578
watercolor heightened with white and gold on vellum
250 x 178 (9 ⅞ x 7)
Woodner Family Collection
See illustration on cover.

cat. 14. Francisco Ribalta,
Presentation of the Virgin in the Temple

10
Federico Barocci
Italian, c. 1535–1612
Head of a Bearded Man, 1579–1582
colored chalks on blue paper
380 x 263 (14 15/16 x 10 3/8)
Woodner Family Collection

11
Cherubino Alberti
Italian, 1553–1615
Giovanni Alberti
Italian, 1558–1601
Prudence (recto and verso), 1596–1602
red chalk, 287 x 177 (11 1/4 x 7)
Gift of Professor William B. O'Neal, in Honor of the
Fiftieth Anniversary of the National Gallery of Art
See illustrations on page 17.

12
Hans Jakob Nüscheler
Swiss, 1583–1654
Elisha Watching Elijah in the Fiery Chariot, c. 1600
pen and brown ink, oval: 183 x 258 (7 3/16 x 10 1/8)
Gift of Eva S. Dencker, in Honor of the Fiftieth
Anniversary of the National Gallery of Art

cat. 12. Hans Jakob Nüscheler, *Elisha Watching Elijah in the Fiery Chariot*

13

Ottavio Leoni

Italian, c. 1578–1630

Young Woman with Braided Hair and a Veil, c. 1610

black chalk heightened with white on blue paper

270 x 193 (10 ⅝ x 7 ⅝)

Ailsa Mellon Bruce Fund

See illustration on page 18.

14

Francisco Ribalta

Spanish, c. 1555–1628

Presentation of the Virgin in the Temple, c. 1620

pen and brown ink and brown washes over black

chalk, squared for transfer, 280 x 187 (11 x 7 ⅜)

Gift of Professor William B. O'Neal, in Honor of the

Fiftieth Anniversary of the National Gallery of Art

15

Aegidius Sadeler

Flemish, c. 1570–1629

The Martyrdom of Saint Sebastian, c. 1620

black chalk with brown and gray wash heightened with

white, 414 x 315 (16 ⁵⁄₁₆ x 12 ⁷⁄₁₆)

Pepita Milmore Memorial Fund

See illustration on page 15.

16

Rembrandt van Rijn

Dutch, 1606–1669

The Ship of Fortune, 1633

etching, 112 x 166 (4 ⅜ x 6 ½)

illustration in Elias Herckmans' *Der Zee-Vaert Lof*

(Amsterdam, 1634)

Anonymous Gift, in Honor of the Fiftieth Anniversary

of the National Gallery of Art

See illustration on page 19.

17

Matteo Rosselli

Italian, 1578–1650

Standing Man Wearing a Cloak and Hat, 1640s

red chalk, 325 x 196 (12 ¹³⁄₁₆ x 7 ¾)

Gift of Professor William B. O'Neal, in Honor of the

Fiftieth Anniversary of the National Gallery of Art

18

Stefano Della Bella

Italian, 1610–1664

Two Men in Masque Costumes, c. 1645

pen and brown ink over graphite

133 x 142 (5 ¼ x 5 ⅝)

Ailsa Mellon Bruce Fund

See illustration on page 18.

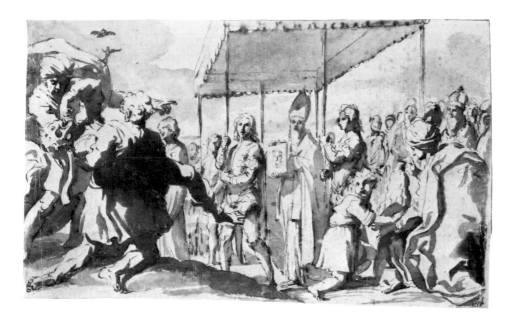

19
Wenceslaus Hollar
Czechoslovakian, 1607–1677
Shell [Vasum ceramicum], c. 1645
etching, 97 x 142 (3 ¹³⁄₁₆ x 5 ⅝)
Gift of Edward William Carter and Hannah Locke
Carter, in Honor of the Fiftieth Anniversary of the
National Gallery of Art
See illustration on page 19.

20
Wenceslaus Hollar
Czechoslovakian, 1607–1677
Shell [Murex brabdaris], c. 1645
etching, 95 x 136 (3 ¾ x 5 ⅜)
Gift of Edward William Carter and Hannah Locke
Carter, in Honor of the Fiftieth Anniversary of the
National Gallery of Art
See illustration on page 19.

21
Giovanni Andrea Sirani
Italian, 1610–1670
Healing of a Possessed Man, c. 1650
pen and brown ink and brown washes heightened with
white over graphite, 149 x 240 (5 ⅞ x 9 ⁷⁄₁₆)
Gift of Sydney J. Freedberg, in Honor of the Fiftieth
Anniversary of the National Gallery of Art

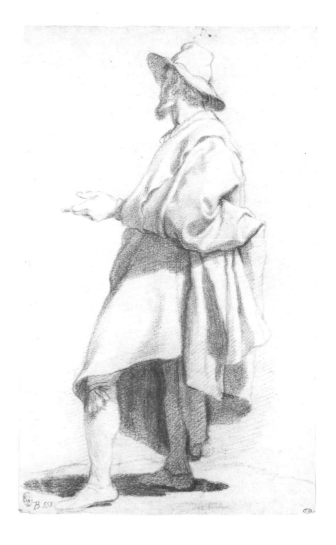

cat. 17. Matteo Rosselli, *Standing Man Wearing a Cloak
and Hat*

cat. 24. Michael Lukas Leopold Willmann, *The Death of Priam*

cat. 23. Robert Nanteuil, *Michel de Marolles*

22

Giovanni Benedetto Castiglione
Italian, c. 1609–1664
Noah Leading the Animals into the Ark, c. 1655
brush and oil, 395 x 548 (15 ½ x 21 ⁹/₁₆)
Gift (Partial and Promised) of Gilbert Butler, in Honor
of the Fiftieth Anniversary of the National Gallery
of Art
See illustration on page 6.

23

Robert Nanteuil
French, 1623–1678
Michel de Marolles, 1657
engraving, 164 x 106 (6 ½ x 4 ³/₁₆)
illustration in *Les Memoires de Michel de Marolles, Abbé de
Villeloin*, 2 vols. in 1 (Paris, 1656 and 1657)
Gift of Mr. and Mrs. Pierre Berès in Memory of Lessing
Rosenwald and in Honor of the Fiftieth Anniversary of
the National Gallery of Art

24

Michael Lukas Leopold Willmann
German, 1630–1706
The Death of Priam, c. 1660
pen and brown ink and brown washes over graphite
213 x 306 (8 ⅜ x 12 ¹/₁₆)
Ailsa Mellon Bruce Fund

Rococo and Neoclassicism

MARGARET MORGAN GRASSELLI

IN THE COURSE OF THE National Gallery's first fifty years, its collection of eighteenth-century prints and drawings has become one of its special strengths. The French and Italian schools have enjoyed continuous growth from the Gallery's very inception; the German and English schools, on the other hand, have only recently been targeted as collecting priorities, though already with marked success. Gifts and purchases made within the past year have continued to add notable works in all areas.

The Gallery's collection of eighteenth-century Italian prints and drawings has its greatest concentration in works by Venetian artists from Tiepolo to Piranesi to Canaletto. A major gap, though, has been a prime work by Sebastiano Ricci, one of the masters who restored Venice to artistic greatness at the beginning of the century. Thanks to the generosity of Mrs. Rudolf J. Heinemann we were able to purchase the beautiful *Ecstasy of Saint Francis* dating from the 1720s (cat. 27). Although the drawing has not been connected with any of Ricci's known paintings, its freely calligraphic pen work, atmospheric washes, sparkling light, and the sweetly ecstatic faces of the angels and the saint make this a fortunate beginning to the Gallery's collection of Ricci's drawings.

The Gallery has been blessed with several excellent pen and wash drawings by the most famous eighteenth-century Venetian artist, Giovanni Battista Tiepolo, but it was not until this past year that we were able to purchase one of his striking red- and white-chalk drawings on blue paper, *Three Cherubs and a Beribboned Staff* (cat. 29, see page 44). Since both the paper and the chalk are extraordinarily well preserved, apparently as bright and fresh as they must have been in Tiepolo's own time, this sheet presents with unusual clarity and brilliance the pure beauty of the artist's line, the boldness of his light, and the richness of his color. The subject matter, too, is particularly delightful. Since many such chalk drawings are now thought to be copies by the young Giandomenico Tiepolo (1727–1804) after his father's paintings, it is especially important to note that the studies on this sheet, apparently executed in the same chalks in a single drawing session, are related to two paintings that were made not only in different years, but also in different countries: two of the putti and the staff were used by Tiepolo in *Saint Roch and Saint Sebastian*, an altarpiece painted for the parish church of Noventa Vicentina around 1750; the third putto was used in *Fall of the Rebel Angels* painted for the chapel of the Residenz in Würzburg, Germany, in 1751–1752. This drawing is thus confirmed as the work of Tiepolo *père*, who made the drawing before he left Venice for Germany but kept it in his portfolio for future reference.

A very different aspect of Tiepolo's art is represented by his etching *Discovery of the Tomb of Punchinello* (cat. 30), the gift of Christopher Mendez. One of the most beautiful images from Tiepolo's enigmatic series of twenty-three *scherzi*, this impression of the relatively rare first state is pre-

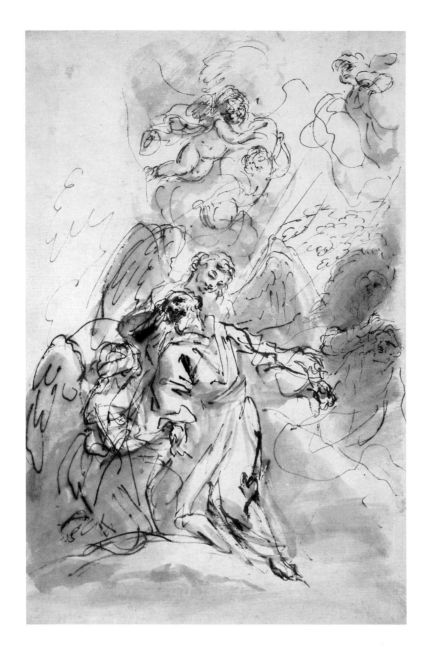

cat. 27. Sebastiano Ricci,
The Ecstasy of Saint Francis

sented on paper that was watercolored a striking yellow-green. The natural assumption is that this had been made as a special trial proof on prepared paper by Tiepolo himself. In fact, though, the color lies over the etched lines and must have been added sometime after the impression was pulled. Andrew Robison has suggested that this was done to transform the etching into a false artist's proof, noting its similarity to watercolored

impressions of sixteenth-century prints that are preserved in an album assembled by the great French collector Pierre-Jean Mariette, now in the Metropolitan Museum of Art, New York. Several years ago, based on close study of those prints, Robison concluded that these were "false rarities," possibly manufactured by Mariette himself (see *Paper in Prints*, Washington, 1977, p. 51, note 56). He has also observed that these correspond to

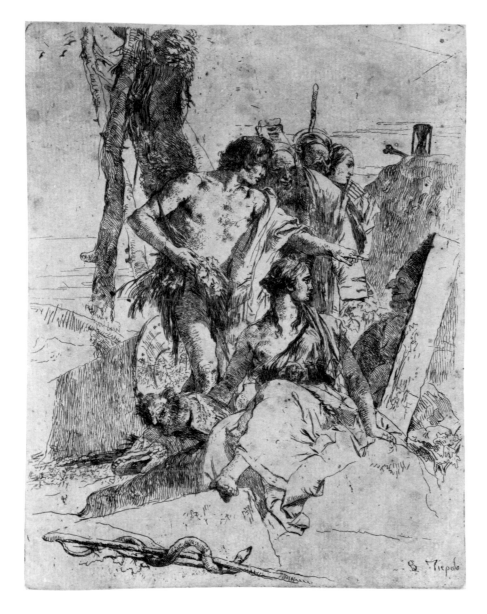

cat. 30.
Giovanni Battista Tiepolo,
The Discovery of the Tomb of Punchinello

other false rarities produced in the circle of Mariette and the printer Pierre Basan such as Callots on silk and Rembrandts in red ink. Since we have evidence that Mariette was sent some early impressions of Tiepolo *scherzi*, it is tempting to take the leap of faith and place this particular print in Mariette's or Basan's own hands and to attribute to one of them the watercoloring that makes this impression "unique." In any case, this

is a most intriguing work that happens to be a perfect complement to the Gallery's album of rare (and authentic) *scherzi* proofs touched with pen.

Very different from Tiepolo's small, delicately etched print is the large, bold, heavily inked *Veduta delle Cascatelle a Tivoli* (Small Waterfall and Rapids at Tivoli) by the greatest, most inventive printmaker of the Italian eighteenth century, Giovanni Battista Piranesi (cat. 37). The gift of Dr.

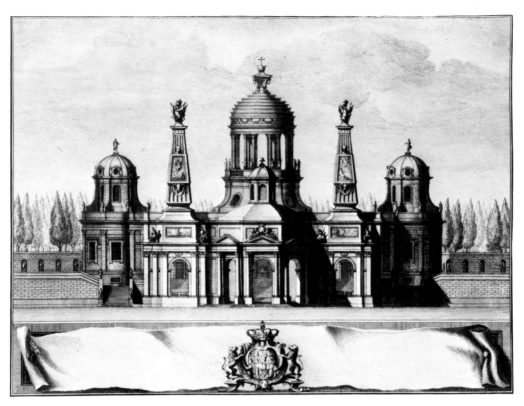

cat. 28. Giuseppe Vasi, *Sepulcher for the King of France*

and Mrs. George Benjamin Green, this imposing print is a relatively rare first state of one of Piranesi's great Views of Rome, which was previously represented in the collection only by the second state. Since acquisitions over the past two decades have given the Gallery the finest collection of Piranesi prints in the United States, the addition of a new state such as this is characteristic of the Gallery's goals.

Unlike Piranesi's deeply bitten and highly pictorial print is the bright proof before the letters of the *Sepulcher for the King of France* by the Roman architect and etcher Giuseppe Vasi (cat. 28), the gift of Henry Millon, dean of the National Gallery's Center for Advanced Study in the Visual Arts, and his wife, Judith Rice Millon. Vasi was, in fact, Piranesi's etching teacher for six months, c. 1741–1742, when the younger artist made his first trip to Rome. Vasi himself was something of an innovator in developing a vocabulary for effectively rendering architecture through etching, but only in the banderole at the bottom of the image did

he allow some freedom to his line. In contrast to Piranesi's exuberant view, Vasi's monument is presented with a more reserved formality that nevertheless accords with the seriousness of the building's purpose.

One of the strengths of Professor William B. O'Neal's gift of eighty-eight Continental drawings is an extraordinary array of architectural studies and designs for stage sets by artists of different schools. Since the Gallery has relatively few theatrical drawings of any type and only a small though choice selection of architectural studies, this aspect of the O'Neal gift is particularly important for the collection. One of the most fascinating is *Designs for Palatial Staircases*, a double-sided sheet of pen sketches attributed to Bernardo Bellotto (cat. 47). Questions have been raised about Bellotto's authorship of this type of drawing, though the vibrant pen work and sparkling light of the O'Neal sheet do seem to correspond to similar features in Bellotto's accepted drawings. These brief jottings of architectural and theatrical de-

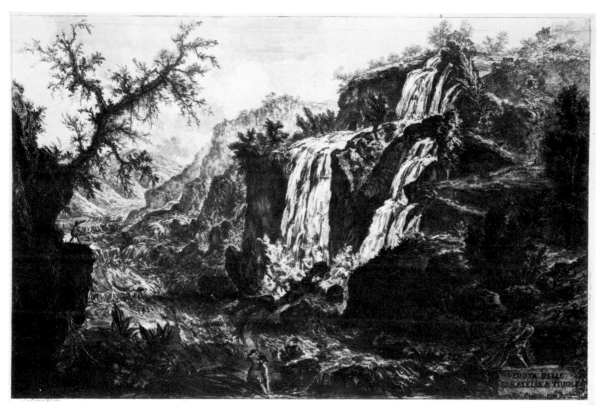

cat. 37. Giovanni Battista Piranesi, *Veduta delle Cascatelle a Tivoli*

signs, however, are quite different from the Venetian views that made Bellotto's reputation, and it seems more likely that the drawing's author will be found in the end among Venice's most talented stage designers working around 1800. Even without a firm attribution, the charm of the individual sketches and the beauty of the sheet as a whole guarantee it a special place within the Gallery's collection of Venetian drawings.

By happy chance, the nucleus of theatrical drawings established by the O'Neal gift is significantly enriched by an exceptionally handsome *Egyptian Stage Design* by Pietro Gonzaga (cat. 46), the gift of Frederick G. Schab. One of the leading theatrical designers of his time, Gonzaga's inventive stage sets were much in demand throughout his career, first in Italy, where he worked in nearly all the major cities, and then in Russia, where he settled in 1790. This impressive drawing, with its Egyptian theme and strongly neoclassical organization, was probably made after his move to St. Petersburg, though the exact purpose

has not yet been determined. It is the first drawing by Gonzaga to enter the collection.

While the Gallery's collection of Venetian prints and drawings is the strength of the eighteenth-century Italian holdings and continues to grow at a remarkable pace, other regional schools of Italy have by no means been neglected. One of the most impressive additions this year is the recently purchased *Triumphal Procession in Ancient Rome* by Gaetano Gandolfi (cat. 41), a member of the most important family of eighteenth-century Bolognese artists. This large, handsome drawing is an exceptionally rich and lively example of his pen and ink compositional studies and most unusual in its extensive use of architecture. The calligraphic pen work describing the figures, the fresh, translucent washes, and the splashes of light imbue the drawing with remarkable spirit.

Traditionally one of the strongest areas of the collection—stronger even than the Italian holdings—is the field of French eighteenth-century prints and drawings. This past year has again

31

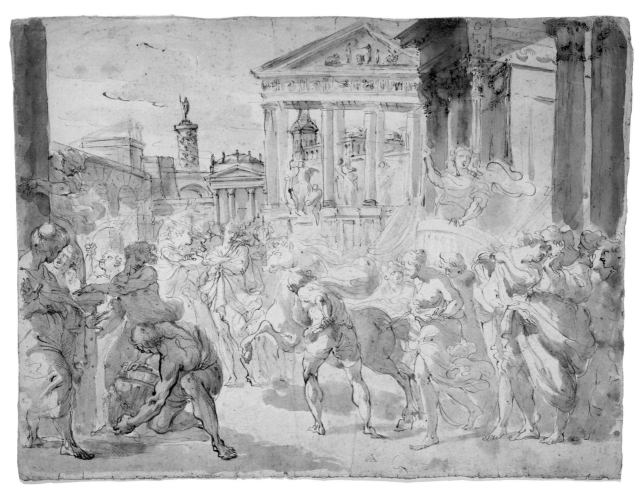

cat. 41. Gaetano Gandolfi, *A Triumphal Procession in Ancient Rome*

brought an embarrassment of riches. The earliest work included here is François Chereau's striking engraving of *Nicolas de Largillierre* (cat. 25), after Largillierre's own self-portrait of 1711. The composition is still steeped in the classical canons of the previous century, though the diagonal gesture and elaborate drapery add some lively sense of movement to the severe geometrical structure of the enframing window. Executed in 1715, the year Chereau was admitted as a provisional member of the French Academy, it is tempting to suggest that this was one of the prints that gained him entry. Even without that cachet, however, this is a particularly fine impression to add to the Gallery's collection of French portrait prints.

More thoroughly eighteenth-century in style

and execution is the sensuous compositional study for a *Diana and Endymion* by an unidentified French artist (cat. 26). Part of the O'Neal gift, it was formerly attributed to François Verdier (1651–1730), an artist whose drawings are entirely seventeenth-century in spirit and wholly different in style and execution from this one. The actual artist most likely belongs to the generation of François Lemoine (1688–1737) and Jean-François de Troy (1679–1752), who led French art into the age of the rococo. The complex squaring over the design indicates that the drawing was the final preparation for a painting, the eventual discovery of which may help to identify the artist. Even without an attribution, however, this splendid composition is an impressive addition to the

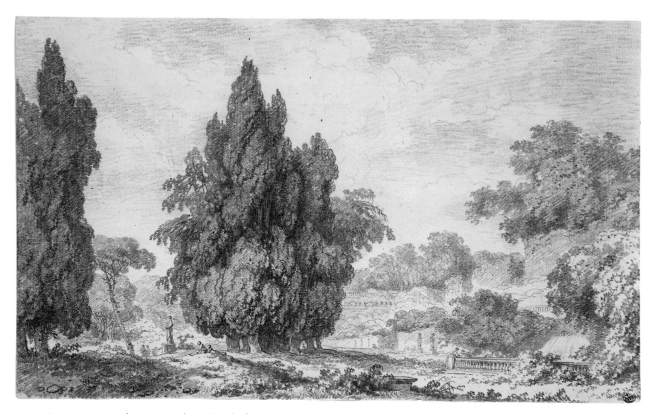

cat. 32. Jean-Honoré Fragonard, *A Stand of Cypresses in an Italian Park*

Gallery's growing group of French drawings dating from the first quarter of the eighteenth century.

No such attribution problem plagues two red-chalk views of Italian parks by two of the greatest lights of French eighteenth-century landscape drawing, Jean-Honoré Fragonard and Hubert Robert. Both the magical *Stand of Cypresses in an Italian Park* by Fragonard (cat. 32), purchased through the Patrons' Permanent Fund, and the engaging *Italian Park with a Tempietto* by Robert (cat. 35), the fiftieth-anniversary gift of Mrs. John A. Pope, are excellent examples of the sun-drenched landscapes through which the two artists first made their reputations. The elements are basically the same: tree-studded parks enlivened by tiny figures, frothy foliage, and anecdotal details. Although Fragonard and Robert occasionally worked in similar manners that are virtually impossible to distinguish, in this case the presentations could hardly be more different. The Fragonard, one of the artist's finest red chalk landscapes anywhere, shows a grand, stately vision drawn with exquisite control. On the other hand, Robert's delightful scene is more casually structured and more broadly and spontaneously executed. Although the Gallery owns several drawings by each artist, none duplicates either of these, which thus add important new dimensions to the holdings.

One of the most charming and perfect expressions of rococo style and sensibility acquired for

cat. 35. Hubert Robert, *Italian Park with a Tempietto*

cat. 25. François Chereau, *Nicolas de Largillierre*

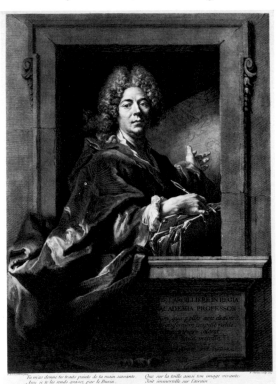

the collection this year is a set of five exquisite color etchings by Anne Allen after *chinoiserie* designs by Jean Pillement, two of which are included here (cats. 33, 34, see page 45). The etcher, about whom little is known, was in fact Pillement's second wife, whom he probably met on one of his many journeys to England. Perhaps because of her special relationship to Pillement, Allen's prints are the most inspired translations into etched form of his sprightly and highly imaginative designs. The delectable examples presented here come from Nouvelle Suite de Cahiers Arabesques Chinois (New Suite of Booklets of Chinese Arabesques) and were probably printed in the early 1760s, when the fashion for things Chinese and Chinese-inspired ornament was at its height.

Almost exactly contemporary with the Allen etchings is the far more somber engraving by Jean-Baptiste Delafosse, *La malheureuse famille Calas* (The Unfortunate Calas Family) after Carmon-

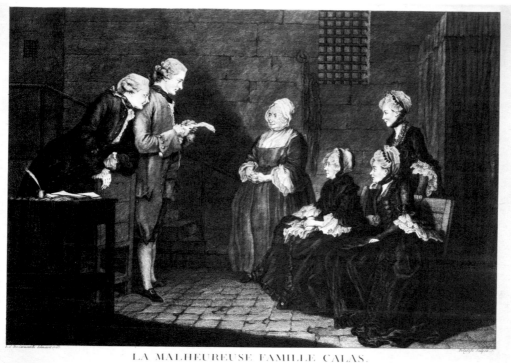

cat. 36. Jean-Baptiste Delafosse, *La malheureuse famille Calas*

telle (cat. 36), one of several portrait prints and drawings given in honor of the Gallery's fiftieth anniversary by John O'Brien. The origins of this handsome print lie in one of the most famous tragedies of the eighteenth century. In 1762 a French Protestant merchant from Toulouse, Jean Calas, was charged with murdering his eldest son who had considered converting to Catholicism. Although the son had in fact committed suicide, the Toulouse parliament yielded to pressure from a group of fanatical monks and condemned the father, who was put to death on the wheel. The great essayist, playwright, and satirist Voltaire publicized this ghastly miscarriage of justice, and the father's conviction was overturned posthumously, in 1765. To compensate the family for their loss and suffering, the critic and journalist Baron von Grimm thought of commissioning a print that would be sold by subscription, the proceeds of which would go to the widow. He asked Carmontelle, whose work as a portraitist he par-

ticularly admired, to produce a drawing; he then commissioned Delafosse, who had already made a number of engravings after Carmontelle's portraits, to make the print. The portrait, Carmontelle's most complex, shows members of the Calas family in the prison cell to which Mme Calas went in early March 1765 as part of the process of vindicating her husband and retrieving his good name. The family's tragic story moved hundreds of people from all walks of life to pay the six *livres* (old French pounds) subscription fee for the print. Voltaire himself ordered ten impressions; Horace Walpole, Diderot, and Mozart were among those who subscribed, as were many members of European royal and noble houses. The print was thus instantly famous and much admired, and we are delighted to have it in the collection.

Also from John O'Brien comes a lively *trois-crayons* study of an unidentified gentleman by Joseph Ducreux (cat. 40, see page 43), whose drawings are very rare outside French and European

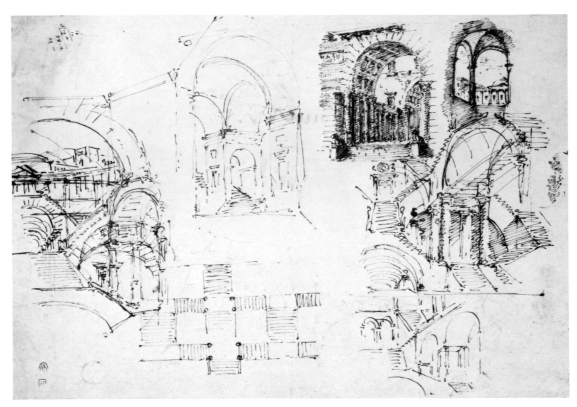

cat. 47. Attributed to Bernardo Bellotto, *Designs for Palatial Staircases*

cat. 46. Pietro Gonzaga, *Egyptian Stage Design*

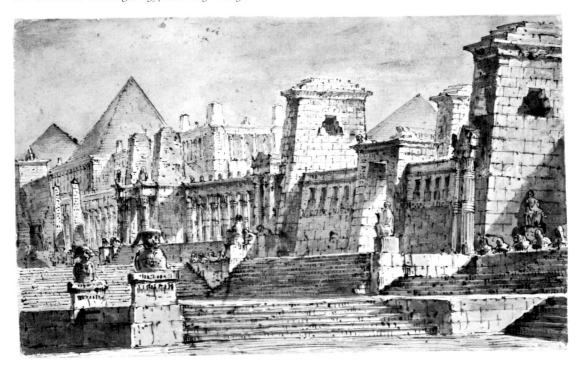

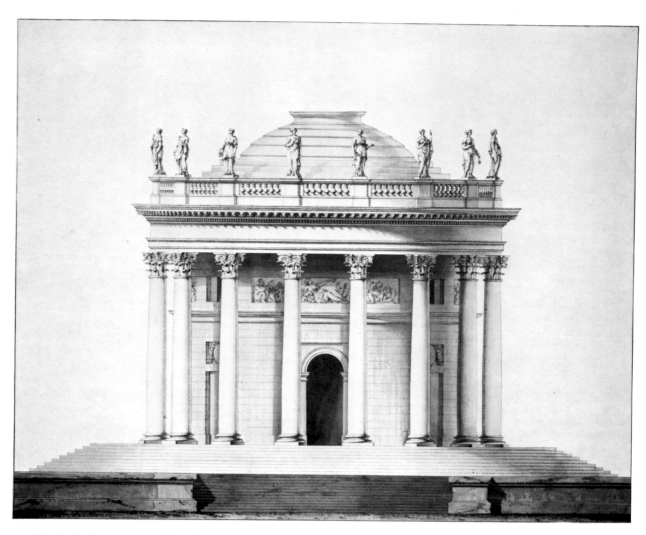

cat. 39. Louis Gustave Taraval, *A Classical Temple*

collections. This refreshingly simple and direct study, the Gallery's first example of his work, was probably made in preparation for a larger portrait in oil or pastel. Although Ducreux is now little known outside his native France, he was first painter to Queen Marie-Antoinette and one of the most sought-after portraitists of his day.

In the last decades of the eighteenth century, public taste in France and Europe shifted away from the rococo toward a more formal, weightier style that was rooted in the ideals of ancient classical art. Nowhere is this change more clearly evident than in the architecture of the period, as the Gallery's new *Classical Temple* by Louis Gustave Taraval (cat. 39) demonstrates. Drawn around

1770, Taraval's elegantly symmetrical temple, with its highly simplified forms and classically inspired elements, clearly conveys the serene grandeur and cool restraint that are specific characteristics of the new taste. Taraval, a Swede who emigrated to Paris as a youth and spent the rest of his life there, rose to become inspector of the king's buildings and was highly influential in establishing the neoclassical style in France. Yet another gift of William B. O'Neal, this excellent drawing is the first by Taraval to enter the collection.

Very different in effect though composed of many of the same architectural elements is Etienne-Louis Boullée's virtuoso *Perspective View of*

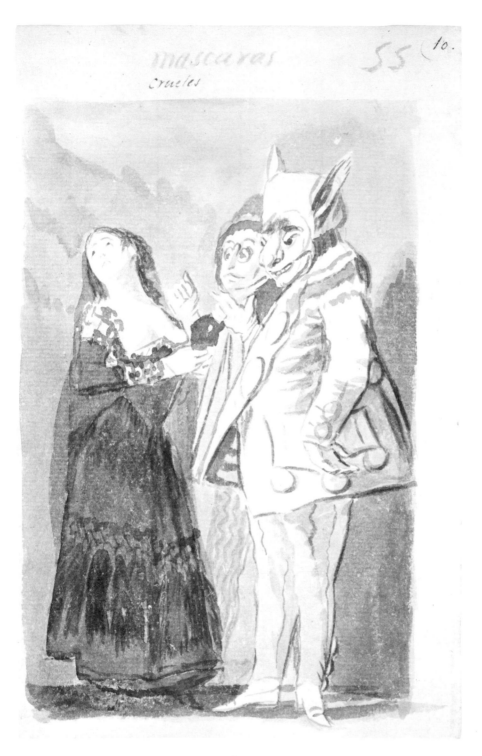

cat. 45. Francisco de Goya, *Mascaras crueles*

the Interior of a Metropolitan Church (cat. 42, see page 3), purchased just this year through the Patrons' Permanent Fund. Like so many of Boullée's visionary projects, this impossibly grand conception was never constructed. But the drawing, with its vast vaults honeycombed with huge coffers, row upon row of Corinthian colonnades, and seemingly endless cornices and architraves, con-

veys the full power of his genius. An unexpected touch of whimsy, the cloud-borne celestial figures that seem to drift down from the dome, helps to relieve some of the overpowering magnificence of the design. Drawings of this scale and importance by Boullée are exceedingly rare outside France: we know of none to match it in the United States. Both this sheet and the excellent Taraval give a boost to the Gallery's small but choice collection of French neoclassical drawings.

While the neoclassical taste so evident in the Taraval and the Boullée was firmly established well before the end of the eighteenth century, the last vestiges of the rococo are still evident in a delightful drawing made by Baron Dominique Vivant-Denon around 1790 (cat. 44, see page 46). Best known as the director of the Musée Napoléon, the precursor of the Louvre, Vivant-Denon was first and foremost an etcher and draftsman who especially enjoyed making informal studies of friends and acquaintances engaged in everyday activities. This beguiling study of a young woman bent over her sewing, probably drawn during the artist's five-year stay in Venice (1788–1793), shows the crisp line, dissolving light, and informal pose that are the hallmarks of his style. It is the Gallery's first by Vivant-Denon. The sheet came to the collection through the Christian Humann Foundation, its third gift in honor of the fiftieth anniversary.

This year has brought several choice acquisitions of major works by artists from other schools as well. First and foremost is the gift from the Woodner Family Collection of the Gallery's very first Goya drawing (cat. 45)—actually two, since the sheet has complete drawings on both sides—

cat. 31. Thomas Gainsborough, *Woods near a Village with Rabbit Catchers and Their Greyhounds*

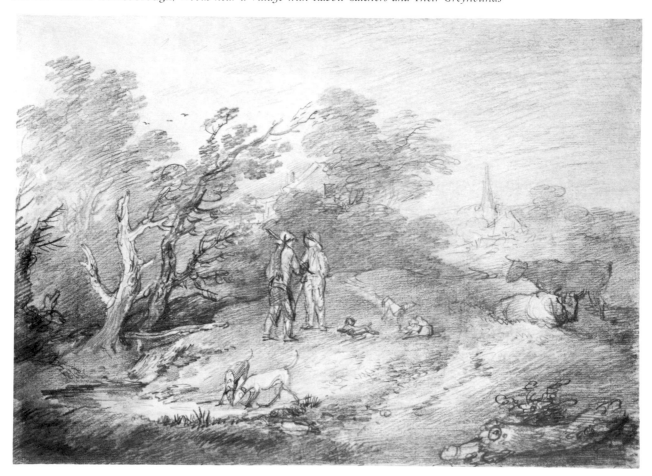

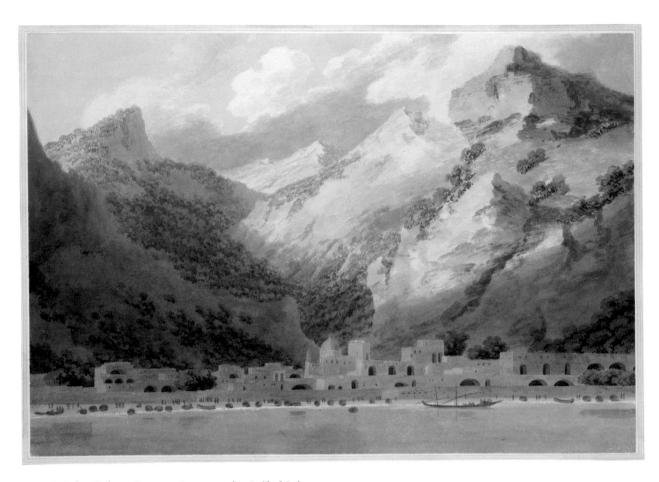

cat. 43. John Robert Cozens, *Cetara on the Gulf of Salerno*

thus filling a void in the Gallery's holdings of Spanish drawings. Once part of an album of ninety-four drawings made around 1797 (the Madrid Album or Album B), *Mascaras crueles* (Cruel Masks) coincides with the beginning of Goya's work on his first famous set of etchings Los Caprichos, published in 1799. Indeed *Brujas à Bolar* (Witches about to Fly) on the verso was etched with some small changes and a different title (*Devota profesion*) for plate 70 of that series. In keeping with the sometimes savagely funny representations of human foibles and failings found in those prints, the depiction on the recto of two masked figures leering at a young woman's exposed breasts has a disturbing note of unpleasantness if not the actual cruelty indicated by the inscribed title.

While it has been particularly difficult to find outstanding Spanish drawings to enrich the collection, fine drawings by German and central European artists have not been quite so elusive. That collection has thus grown quite steadily in recent years. One of the most delightful and unusual additions last year was *Corner of a Rustic Barn* by Sigmund Freudenberger (cat. 38). Though Freudenberger's drawings are plentiful in Europe and particularly in his native Switzerland, they are relatively rare in the United States. Outside Switzerland Freudenberger's reputation still rests, as it did in his own day, on engravings made after his gently erotic and delightfully anecdotal scenes of fashionable life in Paris, where he had lived for eight years (1765–1773). For his private pleasure and for his Swiss patrons, however, he made drawings of a very different world of tumbledown cottages and rural life. As this handsome study of

part of a barn shows, Freudenberger delighted in the everyday details of his Swiss subjects, defining, shaping, and patterning every surface with his bold, broad strokes of the chalk. The Gallery had acquired a fine example of Freudenberger's work as a designer of society pieces several years ago; the barn study, which comes as a fiftieth-anniversary donation from our own Andrew W. Mellon Senior Curator, Andrew Robison, now adds an engaging example of this rarer, more personal side of his art.

The English eighteenth-century collection, meanwhile, has been handsomely enriched by the arrival of outstanding landscape drawings by two of the best draftsmen of the century, Thomas Gainsborough and John Robert Cozens. In contrast to his French contemporaries Fragonard and Robert, who delighted in the sunny landscapes of central Italy, Gainsborough was more attuned to seventeenth-century Dutch landscape and often turned for inspiration to the works of Anthonie Waterloo, Jan van Goyen, and Jacob van Ruisdael among others. *Woods near a Village with Rabbit Catchers and Their Greyhounds* (cat. 31), given by Mrs. Iola S. Haverstick, is an excellent example of how, like his Dutch models, Gainsborough enlivened his country views with charming but ordinary figures, animals, and accidents of nature. Particularly impressive in this drawing of the late 1750s is the dense and richly pictorial use of graphite, a medium that had rarely been used by previous artists to such grand effect. This drawing becomes the Gallery's third example of Gainsborough's work as a landscape draftsman, each one quite different from the others.

While Gainsborough concentrated on the pastoral side of his native English countryside, Cozens preferred more picturesque and exotic locales

cat. 38. Sigmund Freudenberger, *Corner of a Rustic Barn*

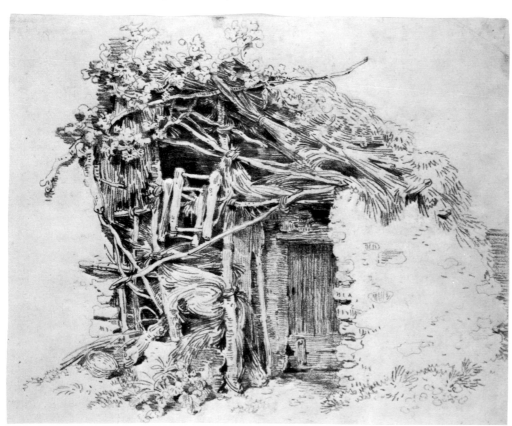

for his large, evocative watercolors. This imposing view of Cetara, a fishing town on the Gulf of Salerno, is one of his most majestic, with the soaring mountains dramatically contrasted against the tiny buildings and boats lining the shore (cat. 43). As is generally the case with Cozens, he made a number of versions of this view, all based on sketches he executed during a seventeen-month trip to Italy in 1782–1783. This one, in which the stark grandeur of the composition is matched by the bold simplicity of the palette, is generally regarded as the most beautiful. Its acquisition through the Patrons' Permanent Fund adds an extraordinary new masterpiece to the collection of British watercolors.

cat. 26. French 18th Century, *Diana and Endymion*

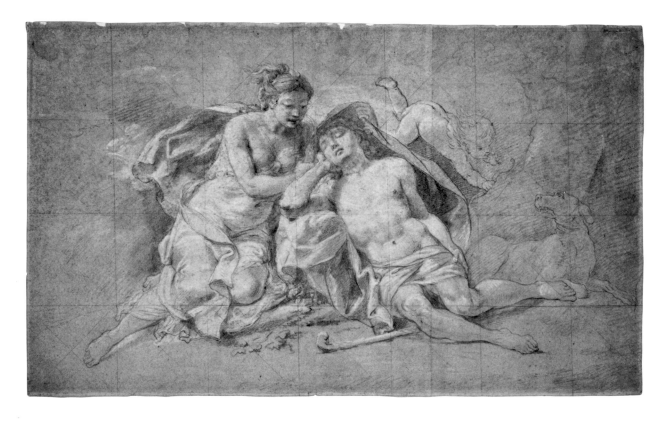

25

François Chereau
French, 1680–1729
Nicolas de Largillierre (after Largillierre), 1715
engraving, 475 x 346 (18 $^{11}/_{16}$ x 13 $^5/_8$)
Ailsa Mellon Bruce Fund
See illustration on page 34.

26

French 18th Century
Diana and Endymion, c. 1720
black chalk heightened with white on brown paper,
squared for transfer, 458 x 760 (18 $^1/_{16}$ x 30)
Gift of Professor William B. O'Neal, in Honor of the
Fiftieth Anniversary of the National Gallery of Art

27

Sebastiano Ricci
Italian, 1659–1734
The Ecstasy of Saint Francis, 1720s
pen and brown ink and brown wash
283 x 182 (11 $^1/_8$ x 7 $^1/_8$)
Gift of Mrs. Rudolf J. Heinemann, in Honor of the
Fiftieth Anniversary of the National Gallery of Art
See illustration on page 28.

28

Giuseppe Vasi
Italian, 1710–1782
Sepulcher for the King of France, c. 1739
etching and engraving, 399 x 530 (15 $^{11}/_{16}$ x 20 $^7/_8$)
Gift of Henry and Judith Rice Millon, in Honor of the
Fiftieth Anniversary of the National Gallery of Art
See illustration on page 30.

29

Giovanni Battista Tiepolo
Italian, 1696–1770
Three Cherubs and a Beribboned Staff, c. 1750
red and white chalks on blue paper
384 x 232 (15 $^1/_8$ x 9 $^1/_8$)
Pepita Milmore Memorial Fund

30

Giovanni Battista Tiepolo
Italian, 1696–1770
The Discovery of the Tomb of Punchinello, early 1750s
etching on paper tinted with yellow-green watercolor
235 x 183 (9 $^1/_4$ x 7 $^3/_{16}$)
Gift of Christopher Mendez, in Honor of the Fiftieth
Anniversary of the National Gallery of Art
See illustration on page 29.

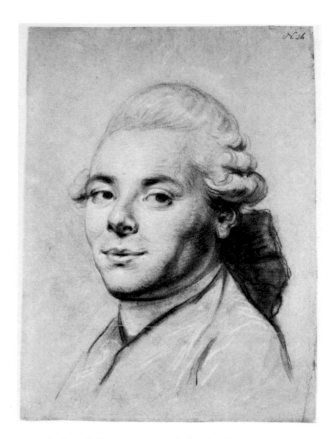

cat. 40. Joseph Ducreux, *Head of a Gentleman*

31

Thomas Gainsborough
British, 1727–1788
*Woods near a Village with Rabbit Catchers and Their
Greyhounds*, late 1750s
graphite, 261 x 368 (10 $^1/_4$ x 14 $^1/_4$)
Gift of Mrs. Iola S. Haverstick in Memory of her Father,
Eugene W. Stetson, and in Honor of the Fiftieth
Anniversary of the National Gallery of Art
See illustration on page 39.

32

Jean-Honoré Fragonard
French, 1732–1806
A Stand of Cypresses in an Italian Park, c. 1760
red chalk, 235 x 377 (9 $^1/_4$ x 14 $^7/_8$)
Patrons' Permanent Fund
See illustration on page 33.

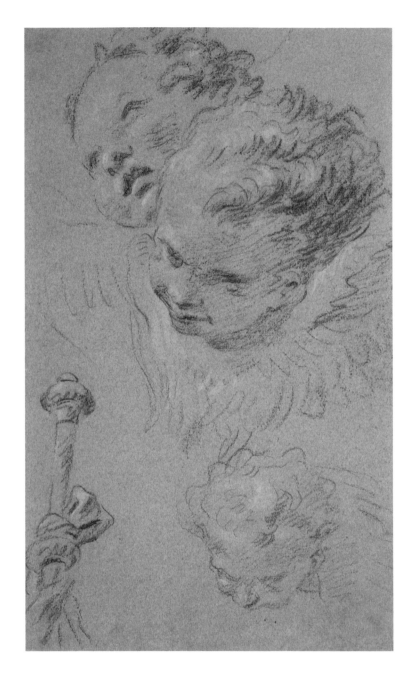

cat. 29. Giovanni Battista Tiepolo,
Three Cherubs and a Beribboned Staff

33
Anne Allen
French, active c. 1760
Chinese Arabesque with a Double Parasol (after Jean
Pillement), early 1760s
color etching, 195 x 139 (7 11/16 x 5 1/2)
Ailsa Mellon Bruce Fund

34
Anne Allen
French, active c. 1760
Chinese Arabesque with a Monkey (after Jean
Pillement), early 1760s
color etching, 193 x 137 (7 5/8 x 5 3/8)
Ailsa Mellon Bruce Fund

35

Hubert Robert
French, 1733–1808
Italian Park with a Tempietto, 1763
red chalk, 315 x 448 (12 ⅜ x 17 ⅝)
Gift (Partial and Promised) of Mrs. John A. Pope, in
Honor of the Fiftieth Anniversary of the National
Gallery of Art
See illustration on page 34.

36

Jean-Baptiste Delafosse
French, 1721–1775
La malheureuse famille Calas (after Carmontelle)
c. 1765
engraving, 360 x 458 (14 ⅛ x 18 1/16)
Gift of John O'Brien, in Honor of the Fiftieth
Anniversary of the National Gallery of Art
See illustration on page 35.

37

Giovanni Battista Piranesi
Italian, 1720–1778
Veduta delle Cascatelle a Tivoli, 1769
etching, 479 x 714 (18 ⅞ x 28 ⅛)
Collection of Dr. and Mrs. George Benjamin Green
See illustration on page 31.

38

Sigmund Freudenberger
Swiss, 1745–1801
Corner of a Rustic Barn, 1770
black chalk, 232 x 283 (9 ⅛ x 11 ⅛)
Gift of Andrew Robison, in Honor of the Fiftieth
Anniversary of the National Gallery of Art
See illustration on page 41.

39

Louis Gustave Taraval
Swedish, 1739–1794
A Classical Temple, c. 1770
pen and black ink with gray, brown, and green washes
415 x 512 (16 5/16 x 20 ⅛)
Gift of Professor William B. O'Neal, in Honor of the
Fiftieth Anniversary of the National Gallery of Art
See illustration on page 37.

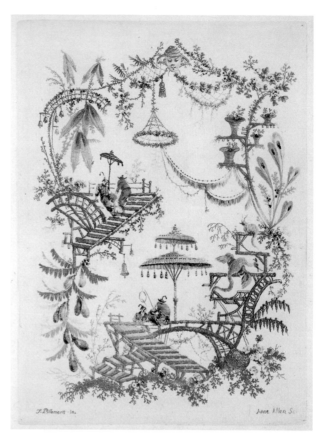

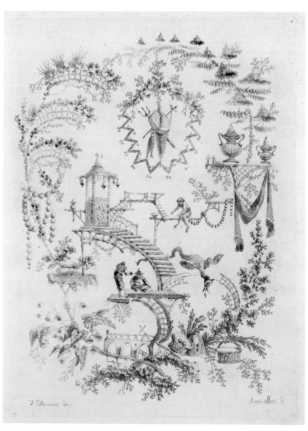

cat. 33. Anne Allen, *Chinese Arabesque with a Double Parasol*

cat. 34. Anne Allen, *Chinese Arabesque with a Monkey*

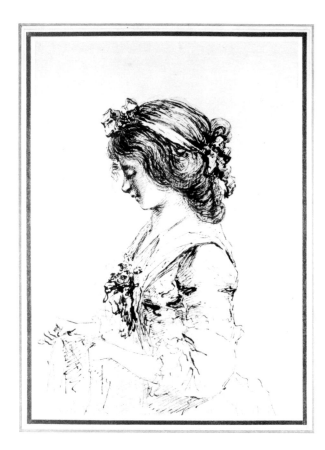

cat. 44. Baron Dominique Vivant-Denon, *A Young Woman Sewing*

40
Joseph Ducreux
French, 1735–1802
Head of a Gentleman, 1770s
red, black, and white chalks with stumping on brown
paper, 385 x 288 (15 ⅛ x 11 ⁵⁄₁₆)
Gift of John O'Brien in Memory of Geneviève
Aymonier and in Honor of the Fiftieth Anniversary of
the National Gallery of Art

41
Gaetano Gandolfi
Italian, 1734–1802
A Triumphal Procession in Ancient Rome, c. 1780
pen and brown ink and brown wash over graphite and
black chalk, 388 x 509 (15 ¼ x 20)
Ailsa Mellon Bruce Fund
See illustration on page 32.

42
Etienne-Louis Boullée
French, 1728–1799
*Perspective View of the Interior of a Metropolitan
Church*, 1780–1781
pen and gray ink with brush and brown wash over
black chalk, 578 x 829 (22 ¾ x 32 ⅝)
Patrons' Permanent Fund
See illustration on page 3.

43
John Robert Cozens
British, 1752–1799
Cetara on the Gulf of Salerno, 1790
watercolor over graphite, 366 x 527 (14 ⅜ x 20 ¾)
Patrons' Permanent Fund
See illustration on page 40.

44
Baron Dominique Vivant-Denon
French, 1747–1825
A Young Woman Sewing, c. 1790
pen and brown ink over graphite on gray-blue paper
164 x 115 (6 ⁷⁄₁₆ x 4 ½)
Gift of the Christian Humann Foundation, in Honor of
the Fiftieth Anniversary of the National Gallery of Art

45
Francisco de Goya
Spanish, 1746–1828
Mascaras crueles, 1796–1797
brush and black ink and gray wash
237 x 150 (9 ⁵⁄₁₆ x 5 ⅞)
Woodner Family Collection
See illustration on page 38.

46
Pietro Gonzaga
Italian, 1751–1831
Egyptian Stage Design, c. 1800
pen and brown ink and gray and brown wash
223 x 633 (8 ¹³⁄₁₆ x 14 ⁵⁄₁₆)
Gift of Frederick G. Schab, in Honor of the Fiftieth
Anniversary of the National Gallery of Art
See illustration on page 36.

47
Attributed to Bernardo Bellotto
Italian, 1721–1780
Designs for Palatial Staircases
pen and brown ink and graphite
290 x 425 (11 ⅜ x 16 ¾)
Gift of Professor William B. O'Neal, in Honor of the
Fiftieth Anniversary of the National Gallery of Art
See illustration on page 36.

Romanticism to Impressionism

ANDREW ROBISON

A NUMBER OF CRUCIAL individual works as well as important complexes were newly added to the National Gallery's holdings of nineteenth-century graphic art. The most recent emphasis in the Gallery's collecting, German romantic drawings, is here represented for the first time. Prints and drawings from the German Renaissance as well as the powerful works of German expressionism have been a priority with the Gallery and its donors for some decades. However, it was the acquisition of the Julius Held Collection in 1984 that brought to the Gallery for the first time a substantial number of German drawings from the eighteenth and nineteenth centuries. For several years we have built on that foundation with success in the area of the eighteenth century. In the nineteenth, the Gallery is now attempting not merely to close the remaining gap in its portrayal of German drawings through the ages, but more positively to represent the intense and sensitive art of German romanticism that is compelling in itself and also one of the bases for our own national school.

One turning point from rococo to romanticism in German landscape is well represented by Adrian Zingg, whose monumental *Rauenstein Castle Seen from the River's Edge* (cat. 48) was acquired through a generous donation by the Christian Humann Foundation. Zingg was the most important landscape draftsman in Dresden from the 1760s virtually until his death in 1816. He continued to use the eighteenth-century tradition of broad topographical views as well as its vocabu-

lary of line and wash, but he gradually transformed the details and the effect of his compositions. The location of the putative subject of the castle in a far distance is not unusual for Zingg. What is new, apparently a development around 1800, is the change from views down and out over a broad prospect to relatively close views onto a subject, rearing up as here. Likewise, while nature was always prominent in Zingg's drawings, the disparity in scale between the natural and the human here becomes extreme. Judged from their closeness to the foreground figures, the reeds, rocks, and vine leaves are now giant in size. Even the beautiful fall of sunlight across the castle, the bridge, and the half-timbered cottage becomes decidedly darker in the lush vegetation nearest to the viewer. All these transformations of an older tradition indicate romantic tendencies; and they help make concrete a few of the possible emotional and stylistic ways, in addition to the technique of sepia drawing, that Zingg may have influenced the young Caspar David Friedrich after he arrived in Dresden in 1798.

As Kurt Meissner is the man most responsible for preserving the work and spreading knowledge of Friedrich Salathé in recent years, it is particularly gratifying that a generous donation from Mr. Meissner has brought to the Gallery three of Salathé's fine drawings in a range of techniques and styles. From his earliest years the Basel artist focused on a rather direct approach to landscape. His *Tower of a Fortified House* of 1814–1815 (cat. 49) shows characteristics of many of his early

cat. 48. Adrian Zingg, *Rauenstein Castle Seen from the River's Edge*

works: a dominant focus on a central motif and the spare outlines with which he created form. It also well illustrates some delightful aspects of Salathé's work that remained throughout his life: the delicate and restrained range of color as well as the characteristically romantic use of ''unfinished'' or reserved areas of the paper to surround a motif or flood a design with brilliant light and also to emphasize the origins and development of the work as a drawing on paper. A second Salathé from the Meissner gift, *Corner of a Garden Court* (cat. 50, see page 58), clearly dates from the artist's years in Italy, 1815–1821. Besides being a bold use of pencil to grasp a motif on the spot, the drawing is also a fine example of the early romantic focus on telling details. What might have been a picturesque interaction between

nature and deteriorating architecture in the eighteenth century, such as the Freudenberger earlier in this exhibition, has here acquired a sharper edge, a sense that the force or life in the image belongs not only to the flood of light but also to the burgeoning variety of plants and flowers bursting over the wall, even to the thrust of the projecting banister and well.

It is well known that the trip to Italy—more, the experience of living in Italy, frequently with other visiting artists—had a crucial effect on the work of many of the German romantics. In a fashion completely different from Salathé's, this effect is reflected in Friedrich Preller's *Italian Coastal Landscape with a Thunderstorm* (cat. 52, see page 58). By contrast with Salathé's direct reaction to nature, Preller's drawing, dating from his

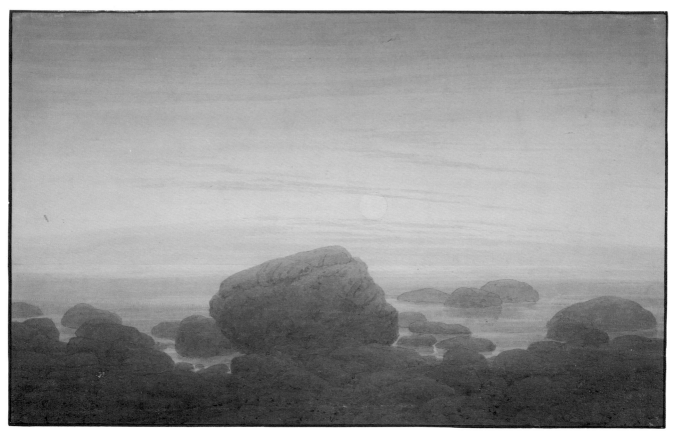

cat. 54. Caspar David Friedrich, *Moonrise on an Empty Shore*

three-year residence in Rome, 1828 to 1831, is clearly composed in the academic tradition of the heroic landscape as practiced by his older compatriot in Rome, Johann Christian Reinhart, and going back to the classical landscapes of Poussin. The turbulent subject has its own romantic aspects, but the most extraordinary feature of Preller's drawing is his remarkably subtle control of color. At first glance a two-tiered stagelike setting with brown in front and gray in back, it is in fact much more unified. A closer look reveals subtle warm undertones carefully placed in the gray distance as well as gray tones beneath the layers of brown in the foreground. It is particularly the latter combination in its interaction with the very delicate white heightening that creates the strange mood of the scene: a telling evocation of the eerie

half-lights caused by a darkened sky at midday and simultaneously a transposition of the action from contemporary reality to an unreal, antique, or even timeless scene.

By far the most famous German romantic artist is Caspar David Friedrich. The Gallery's most recent and most important acquisition in this field and a cornerstone for our collection is a major late Friedrich sepia, *Moonrise on an Empty Shore* (cat. 54). Friedrich made large sepia drawings, or what were sometimes called "sepia paintings," as an important part of his art from his early years. A special status is held by those he executed toward the end of his life, seen by some as a kind of summing up of his art in the medium most comfortable for him after his illnesses. There are seven such sepia variations by Friedrich in the 1830s on

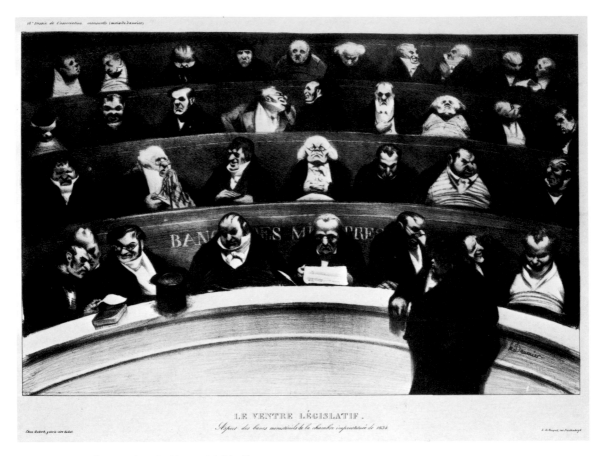

cat. 53. Honoré Daumier, *Le Ventre Législatif*

the theme of a moonrise seen from an empty shore, and this drawing appears to be the culmination of the series.

One might well say that all romantic artists were sensitive to nature, but even in that context Friedrich takes a special place. He not only studied nature as a matter of course around him; but from his mid-twenties he made special and repeated nature trips to the coast of the North Sea, the island of Rügen, and walking trips through various mountain ranges. His art as well as the writings of his friends show his enormous sensitivity focused on the grandeur of nature, its endlessness, but also, in contradistinction to other romantics, its peace, its calm. The contemplation of empty nature—rocks and cliffs, wizened trees, foggy coasts, vast mountains, the glow of sunset, moonrise, the sea—was for him a spiritual communion with the infinite, with divinity. No other artist has captured this meditation as intensely as Friedrich. Some scholars have interpreted the present drawing as having a very specific iconography: the shore representing this life; the sea, existence after death; the moon, Christ enlightening the world; and the central rock, faith in the moment of death. Whether one accepts such a specific reading or not, there is no doubt that for Friedrich religion and nature merged. A genius of the artist is that whatever one's personal religious persuasion, as one studies this beautiful and contemplative drawing an intense sense of meaning in nature and of meditative communion touches one deeply.

While German romantic drawings are a new emphasis for the Gallery, other acquisitions last year added important variations and strengths to areas for which the museum has long been known. The collection of Daumier prints and

50

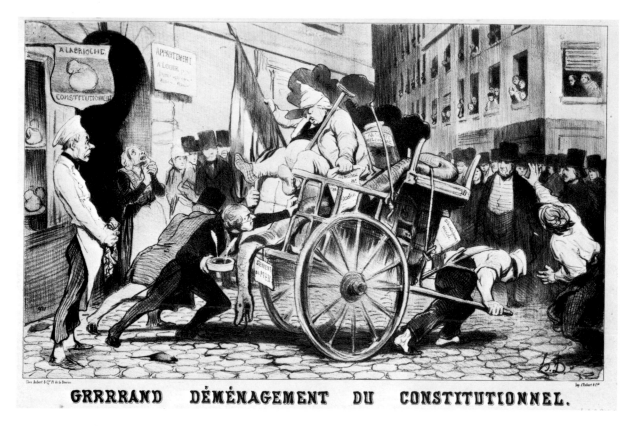

GRRRRAND DÉMÉNAGEMENT DU CONSTITUTIONNEL.

cat. 56. Honoré Daumier, *Grrrrand Déménagement du Constitutionnel*

drawings was initiated within a few years of the Gallery's opening by major donations from Lessing J. Rosenwald and Myron Hofer. Over succeeding decades Rosenwald's gifts of Daumier lithographs acquired a distinctive character: their quantity, though substantial, remained a small percentage of the artist's vast oeuvre; but their quality was extraordinary, eventually amounting to an astounding total of more than 360 rare and beautifully printed proofs before the letters. Since the time of the Rosenwald donations we have continued to seek and add Daumiers every year, further proofs but especially a wider range of subjects in good standard impressions. Only last year, however, a generous donation from Lloyd Cutler and Polly Kraft brought the Gallery a prime desideratum, a truly excellent impression of one of Daumier's most famous lithographs, *Le Ventre Législatif*, 1834 (cat. 53). Much stronger and more

brilliant than the copy already owned by the Gallery, the Cutler impression gives visual punch to this caricature of legislative establishment and venality, strengthening each individual characterization as well as emphasizing the projection in depth that contrasts the receding center of the ministerial benches with the protruding bellies of the legislators. A second important Daumier lithograph was given by Paul McCarron: the 1846 *Grrrrand Déménagement du Constitutionnel* (cat. 56). Unusually large for Daumier's work after 1834 and apparently rare, this is a satire on the right-wing newspaper *Le Constitutionnel*. It is especially noteworthy for Daumier's extraordinary ability to capture a vast range of human expression and gesture as well as his unequaled control of lithographic tone through a wide and seemingly effortless variety of marks with crayon and scratching.

In the field of drawings perhaps the second

51

cat. 49. Friedrich Salathé, *Tower of a Fortified House*

newest emphasis at the Gallery is British drawings and watercolors. Beyond the works of William Blake, the Gallery began to pursue a comprehensive survey of fine examples about 1980 and celebrated the progress to date in an exhibition in 1987. We have continued that program with donations and purchases, as represented earlier in this exhibition by the Gainsborough and the Cozens. In that context it was particularly fortunate to have the opportunity to add the Gallery's first major work by John Ruskin, *The Garden of San Miniato near Florence*, 1845 (cat. 55). This brilliant watercolor encapsulates the creative tension between two of Ruskin's primary desires, truth to nature and to detail, and also—under Turner's influence—expressive freedom. Thus the broad splashes of color, light, and shadow are balanced by scattered and incisive details of vine leaves, roses, and the materials of the crumbling architecture, even to the blue-and-white overdoor. Ruskin never parted with the watercolor and wrote of it more than forty years later that it and one other "remain to me . . . memorials of perhaps the best days of early life."

As with Daumier so with Blake: the Gallery's collection has long been famous, again based pri-

cat. 55. John Ruskin, *The Garden of San Miniato near Florence*

marily on donations from Lessing J. Rosenwald. However, the environment of Blake—his close contemporaries and his followers—has not been as strongly represented. In recent years donations from William B. O'Neal and Paul Mellon, as well as purchases, have helped. And last year a group of works by several members of Blake's circle was added as a fiftieth-anniversary gift from Charles Ryskamp, who has also made important scholarly contributions in this field. From that group we have included in this exhibition several of the most beautiful prints. In 1823 John Linnell commissioned Blake's greatest series of engravings,

the Book of Job, and also was the original owner of many of the finest Blake proofs later purchased by Rosenwald. Linnell himself had earlier created a few delicate and sensitive landscape etchings, of which the Ryskamp gift included the best and the Gallery's first: *Sheep at Noon*, 1818 (cat. 51). Linnell was also responsible for introducing Samuel Palmer to Blake in 1824. It was his memory of early Blake-inspired rustic years that resurged in Palmer's late etchings *The Bellman* (cat. 57) and *The Lonely Tower* (cat. 58), both of 1879, thought by many to be his finest prints. The latter is the Gallery's first impression, while the Ryskamp

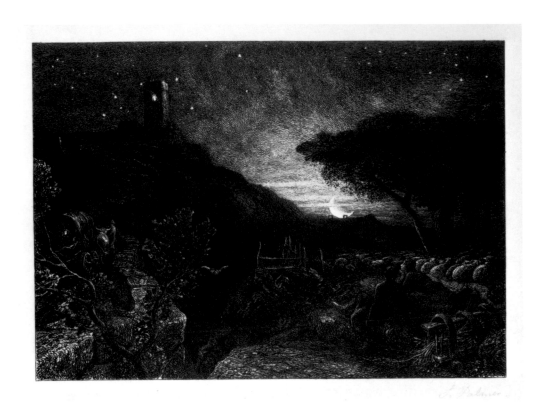

cat. 57. Samuel Palmer, *The Bellman*

cat. 58. Samuel Palmer, *The Lonely Tower*

impression of *The Bellman* is far more luminous than the Gallery's present copy. Besides their powerful sense of pastoral harmony, both Palmers effectively convey what the artist himself called "the charm of etching . . . the glimmering through of the white paper even in the shadows; so that almost everything . . . sparkles."

Recent acquisitions also brought a number of important additions to the Gallery's collection of nineteenth-century American drawings. The greatest watercolorist of the period was unquestionably Winslow Homer. While the collection contains fine examples from several of Homer's periods and themes, a generous donation by Nancy Voorhees has now brought our first watercolor of a Civil War subject, *Two Scouts*, 1887 (cat. 59, see page 56). This unusual subject among Homer's watercolors is explained by two fascinating letters from the artist also given by Ms. Voorhees: in 1865 Homer had made a drawing of the figures from life that so impressed one of Homer's admirers two decades later that he commissioned the watercolor.

Except for the Winslow Homers, the Gallery's fairly young collection of nineteenth-century American drawings has not been strong in works in color. Two recent donations will help to change that. One of Charles Fromuth's most important pastels, *A Dock Harmony—Fishing Boats*, 1897 (cat. 60, see page 59), a fiftieth-anniversary gift from Mr. and Mrs. Robert G. Cleveland, brings our first work by the artist and adds greatly to the Gallery's few American impressionist pastels. Ending the century on a most helpful note, Mr. and Mrs. Paul Borghi gave the Gallery one of its first real surveys of drawings by any artist in this period other than Homer, Whistler, and Cassatt. The Borghi donation of thirty drawings and two prints by the American symbolist Elihu Vedder provides an excellent overview of Vedder's career and subjects from the 1850s through the end of the century. The group is highlighted by fine works in color such as the example included here, *Dawn*, 1898 (cat. 61, see page 57), a lithograph Vedder reworked by hand in colored chalk and gold paint to enhance the glancing backlighting and create a particularly beautiful vision of the allegorical nude.

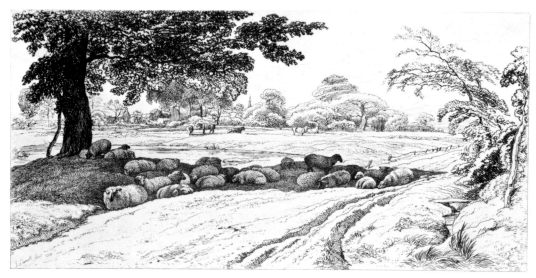

cat. 51. John Linnell, *Sheep at Noon*

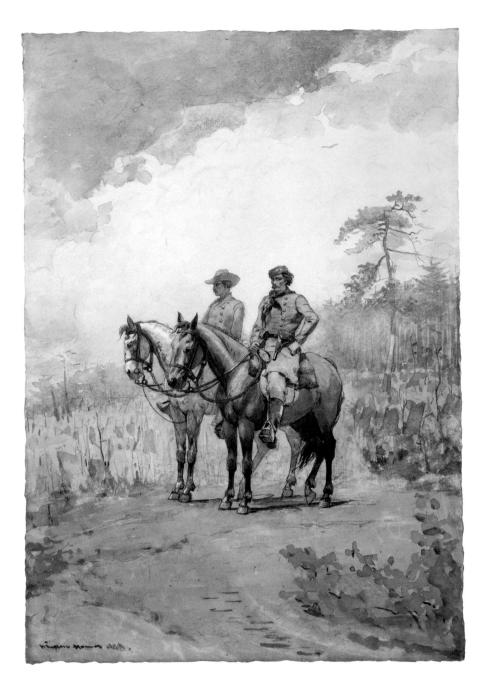

cat. 59. Winslow Homer, *Two Scouts*

48

Adrian Zingg
Swiss, 1734–1816
Rauenstein Castle Seen from the River's Edge, c. 1800
pen and brown ink and brown wash
502 x 683 (19 ¾ x 26 ⅞)
Gift of the Christian Humann Foundation, in Honor of
the Fiftieth Anniversary of the National Gallery of Art
See illustration on page 48.

49

Friedrich Salathé
Swiss, 1793–1858
Tower of a Fortified House, 1814–1815
pen and black ink and watercolor over graphite
440 x 391 (17 ⁵/₁₆ x 15 ⅜)
Gift of Kurt Meissner, in Honor of the Fiftieth
Anniversary of the National Gallery of Art
See illustration on page 52.

50
Friedrich Salathé
Swiss, 1793–1858
Corner of a Garden Court, 1815–1821
graphite, 235 x 335 (9 ¼ x 13 ³/₁₆)
Gift of Kurt Meissner, in Honor of the Fiftieth
Anniversary of the National Gallery of Art

51
John Linnell
British, 1792–1882
Sheep at Noon, 1818
etching, 140 x 230 (5 ½ x 9 ¹/₁₆)
Gift of Charles Ryskamp, in Honor of Paul Mellon and
in Honor of the Fiftieth Anniversary of the National
Gallery of Art
See illustration on page 55.

52
Friedrich Preller
German, 1804–1878
Italian Coastal Landscape with a Thunderstorm
1828–1831
pen and red-brown ink with red-brown and gray wash
heightened with white over graphite
232 x 325 (9 ⅛ x 12 ¹³/₁₆)
Ailsa Mellon Bruce Fund

53
Honoré Daumier
French, 1808–1879
Le Ventre Législatif, 1834
lithograph, 349 x 526 (13 ¾ x 20 ¾)
Gift of Lloyd Cutler and Polly Kraft, in Honor of the
Fiftieth Anniversary of the National Gallery of Art
See illustration on page 50.

54
Caspar David Friedrich
German, 1774–1840
Moonrise on an Empty Shore, 1837–1839
sepia washes over graphite
252 x 195 (9 ¹⁵/₁₆ x 15 ½)
Patrons' Permanent Fund
See illustration on page 49.

55
John Ruskin
British, 1819–1900
The Garden of San Miniato near Florence, 1845
watercolor and pen and black ink heightened with
white over graphite, 342 x 492 (13 ½ x 19 ⅜)
Patrons' Permanent Fund
See illustration on page 53.

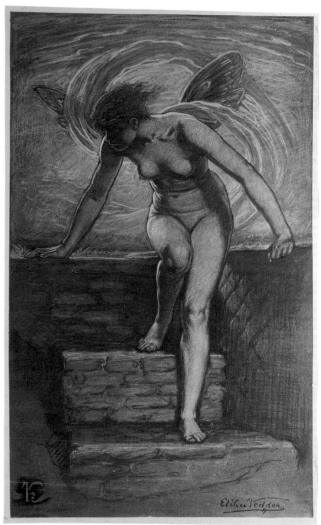

cat. 61. Elihu Vedder, *Dawn*

56
Honoré Daumier
French, 1808–1879
Grrrrand Déménagement du Constitutionnel, 1846
lithograph, 306 x 510 (12 ¹/₁₆ x 20 ¹/₁₆)
Gift of Paul McCarron, in Honor of the Fiftieth
Anniversary of the National Gallery of Art
See illustration on page 51.

57
Samuel Palmer
British, 1805–1881
The Bellman, 1879
etching, 192 x 253 (7 ⁹/₁₆ x 10)
Gift of Charles Ryskamp, in Honor of Paul Mellon and
in Honor of the Fiftieth Anniversary of the National
Gallery of Art
See illustration on page 54.

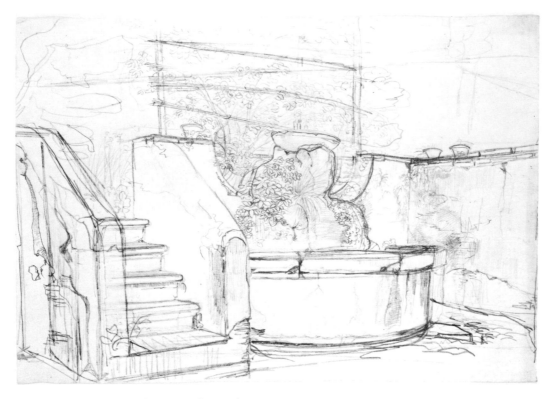

cat. 50. Friedrich Salathé, *Corner of a Garden Court*

cat. 52. Friedrich Preller, *Italian Coastal Landscape with a Thunderstorm*

cat. 60. Charles Fromuth,
A Dock Harmony—Fishing Boats

58
Samuel Palmer
British, 1805–1881
The Lonely Tower, 1879
etching, 190 x 253 (7 ½ x 10)
Gift of Charles Ryskamp, in Honor of Paul Mellon and
in Honor of the Fiftieth Anniversary of the National
Gallery of Art
See illustration on page 54.

59
Winslow Homer
American, 1836–1910
Two Scouts, 1887
watercolor over graphite
505 x 354 (19 ¹⁵/₁₆ x 13 ¹⁵/₁₆)
Gift of Nancy Voorhees, in Honor of the Fiftieth
Anniversary of the National Gallery of Art

60
Charles Fromuth
American, 1861–1937
A Dock Harmony—Fishing Boats, 1897
pastel on dark brown paper, 608 x 459 (23 ¹⁵/₁₆ x 18)
Gift of Mr. and Mrs. Robert G. Cleveland, in Honor of
the Fiftieth Anniversary of the National Gallery of Art

61
Elihu Vedder
American, 1836–1923
Dawn, 1898
crayon, gouache, gold paint, and graphite over
photolithograph, 379 x 230 (14 ¹⁵/₁₆ x 9 ¹/₁₆)
Gift of Mr. and Mrs. Paul Borghi, in Honor of the
Fiftieth Anniversary of the National Gallery of Art

cat. 82. Milton Avery, *Birds and Sea* (artist's proof)

cat. 83. Milton Avery, *Birds and Sea* (artist's proof)

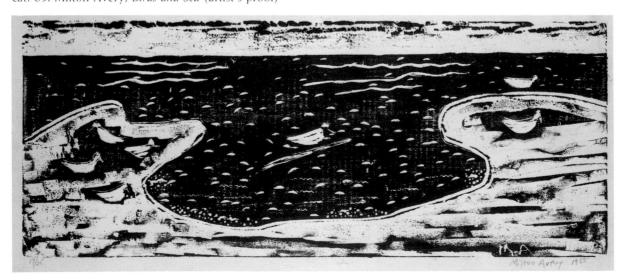

cat. 84. Milton Avery, *Birds and Sea*

The Early Twentieth Century

SARAH GREENOUGH

LIKE OTHER AREAS OF THE National Gallery's collection, our holdings of early twentieth-century prints, drawings, and photographs were greatly enhanced in our fiftieth-anniversary year. Most of these acquisitions were made through gifts from new donors as well as those who have generously and consistently supported the Gallery in the past; a few important purchases were also made. In each case these additions richly complement and significantly expand our collection, allowing us to present a much broader picture of the development of twentieth-century art; in several instances, because of the depth of the acquisition, these gifts enable us to preserve major repositories of individual artists' work.

Unquestionably one of the most important additions to our collection of twentieth-century European work is the eight prints by Ernst Ludwig Kirchner given by Ruth and Jacob Kainen, five of which are presented in this exhibition. Including three woodcuts and two lithographs, these prints demonstrate Kirchner's extensive investigation of different printing processes as well as his experimental use of paper—exploring its weight, texture, and color—over a period of thirteen years. The earliest, *Windmill near Burg on Fehmarn* (cat. 65), a lithograph from 1908, and *Girls from Fehmarn* (cat. 66), a woodcut from 1913, were both made on a remote island in the Baltic off the coast of Schleswig-Holstein. Both are also excellent examples of Kirchner's exploration of the physical properties of these different printing techniques. Utilizing the fluid and painterly character-

istics of the lithograph, Kirchner created a flowing vista of clouds and landscape that seem to float across the translucent sheet of japan paper in *Windmill near Burg on Fehmarn*. In *Girls from Fehmarn*, as well as in *Fanny Wocke* (cat. 68, see page 78) and *The Wife of Professor Goldstein* (cat. 69, see page 8), woodcuts from 1916, he exploited the raw, angular, even violent qualities of the wood to construct images of remarkable psychological intensity. The two woodcuts from 1916 were both printed on thick blotting paper that further heightens the rough-hewn quality of the images just as the bright yellow paper of the *Girls from Fehmarn* intensifies the subjects' masklike faces. This investigation of the expressive potential of paper can also be seen in the last work in this group, *Portrait of a Girl (L's Daughter)* (cat. 71, see page 76), a rare lithograph from 1921 printed on a delicate rose-colored paper. With these gifts the Gallery now has a collection of thirty Kirchner prints, making it an important repository of this artist's work.

Our collection of European portraits, self-portraits, and figure studies was also significantly expanded in 1991. One of the earliest is Gwen John's penetrating *Self-Portrait* (cat. 64), a black chalk drawing dated between 1907 and 1909. Only the second work by this British artist to enter the Gallery's collection, it was purchased with funds donated by Mr. and Mrs. James T. Dyke. On first glance it is a simple and unassuming work: the hair and clothing are indicated with only a few swiftly drawn lines, while the short,

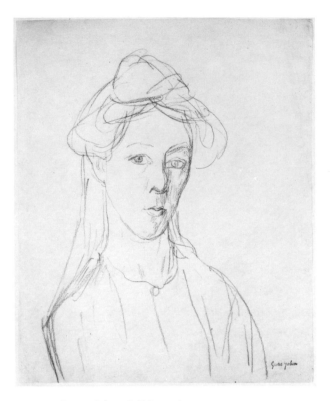

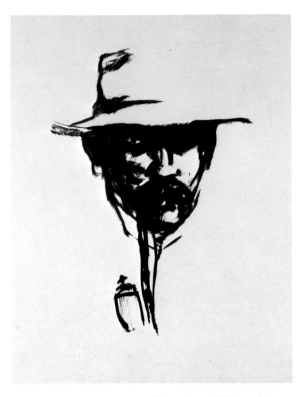

cat. 64. Gwen John, *Self-Portrait*

cat. 63. Emil Nolde, *Man with a Pipe (Self-Portrait)*

more labored strokes of the face, particularly the eyes, command our attention. By combining a still countenance with a highly charged and concentrated focus on the eyes, John created a compelling image that speaks to the intense scrutiny with which the artist examined both herself and the world around her. This process of self-examination is also seen in Emil Nolde's superb lithograph from the same time, *Man with a Pipe (Self-Portrait)* (cat. 63), a purchase made possible by the Ailsa Mellon Bruce Fund. Less intense and more brooding than the John drawing, this work is again centered on the artist's eye. The hat and pipe are only suggested, as are the other details of the face—nose, chin, and mouth—while the brim of the hat plunges much of the rest of the face into deep shadow. Yet out of this blackness the artist's white eye stares and acutely observes the world.

Picasso's *Sculptor at Rest before a Bacchanal with a Bull* (cat. 76, see page 73), a 1933 etching from the Vollard Suite and one of three prints from this series given by Lesley Ryan, also addresses the issue of the artist as observer. Although the sculptor

depicted in this etching is surrounded by a scene of wild abandon—writhing nude figures and a prancing bull—he himself is not a participant but rather a detached witness. Both this print and another gift from Lesley Ryan, *Two Nudes Resting* (cat. 75, see page 72), a drypoint etching from 1931, are excellent examples also of Picasso's remarkable ability to use the most minimal calligraphic line to describe full, voluminous forms.

The Gallery's representation of Matisse's work was greatly augmented with the gift of his drawing *Reclining Nude*, 1935 (cat. 78, see page 72), a gift from Henry and Mabel Brandon, and the Limited Editions Club publication of James Joyce's *Ulysses*, 1935 (cat. 77, see page 77), a gift from Mrs. H. Dunscombe Colt, which is illustrated with six soft-ground etchings by Matisse as well as reproductions of the preliminary drawings. Although the Gallery is extremely fortunate to have many paintings, prints, drawings, and collages by this prolific artist, very few date from the 1930s. In the etchings and in the drawing, Matisse seems to have been just barely able to squeeze his com-

62

cat. 72. Lovis Corinth, *Sigbert Marzynski*

cat. 73. Paul Klee, *Old Man Reckoning*

position into the sheet of paper. Flowing from edge to edge, these works are beautiful, complex, yet elegant examples of Matisse's consummate draftsmanship.

Paul Klee's satirical yet whimsical *Old Man Reckoning* (cat. 73), an etching on black paper given by Frank R. and Jeannette H. Eyerly, is a superb example of one of the last prints of this important Swiss artist. Like so much of Klee's art, it addresses both man's failings and his endearing qualities. The seemingly half-witted, toothless, and hairless old man stares with square (and presumably uncomprehending) eyes into the distance as he computes sums, like a child, on his fingers.

From approximately the same time, Sir Muirhead Bone's watercolor *Calm on the Mediterranean* (cat. 70, see page 74) is also a welcome addition, one of seven given by Mortimer Brandt. Bone, an Englishman who traveled widely, was already well represented in the Gallery's collection with a large group of drawings and prints primarily from the Rosenwald Collection. Yet despite this rich holding, *Calm on the Mediterranean*, with its beautifully poetic, watery washes that are almost abstract in their simplification, is unlike anything in our collection.

This year the Gallery was extremely fortunate to receive a few gifts that, because of their scope and depth, immediately established major repositories for the study of an artist's career: one of these was the gift by the Marcy family—including Toni G. Marcy, S. Michael and Joan Marcy, and Stephanie N. Marcy—of 129 prints by Lovis Corinth. Sigbert H. Marcy, who amassed the collection and whose portrait by Corinth is included in this exhibition (cat. 72), was a close friend of Corinth's and thus had the opportunity to obtain works of the highest quality from the artist. As is evidenced in this group, Marcy was committed to preserving not only the full range of his friend's graphic art, but also examples in the finest condition.

Another extremely important key set that was donated to the Gallery in 1991 was the Milton Avery Collection, a gift of the Avery family. The eighty-four prints and forty-two plates and blocks include one example of every print Avery made that was not previously owned by the Gallery. Like his paintings and drawings, these prints depict the subjects that were his inspiration throughout his career: family and friends, the nude and

63

cat. 66.
Ernst Ludwig Kirchner,
Girls from Fehmarn

nature. Included in this exhibition are three impressions of the woodcut *Birds and Sea* (cats. 82, 83, 84), all printed from the same block (which is also in the Gallery's collection) and each a different color: one very dark blue, one black, and one brown and black. The simplified forms and textured surfaces of *Birds and Sea* speak of the joyous rapture that Avery experienced when looking at the natural world.

Like Avery, many other American artists of the early twentieth century were deeply committed to nature and more specifically to the American landscape. In 1991 the Gallery was particularly fortunate to receive two excellent watercolors that significantly expand our holdings of this important subject. The earliest is a gift from Ira Spanierman of a 1916 watercolor, *Rail Fence* (cat. 67), by Charles Burchfield. Only the second work by this American artist to enter the Gallery's collection, it is a superb example of Burchfield's early style. While the subject is ordinary and simple—a split rail fence separating a rich green field from a brown and empty one—the resulting image is far from common. The complicated interweaving of

cat. 65. Ernst Ludwig Kirchner, *Windmill near Burg on Fehmarn*

the forms of the fence and the shadows they cast creates an intricate abstract pattern that enlivens the entire sheet of paper. The dramatic compositional thrust of the fence is balanced by a few vertical elements, such as the bluebird sitting on one of the rails, that add a point of calm and rest in this otherwise dynamic image. Arthur Dove's 1937 watercolor *From Cows* (cat. 79, see page 71), a gift from Mr. and Mrs. William C. Janss, is another outstanding addition to our holdings. Dove is one of the most important American artists of the early twentieth century, yet prior to 1991 the Gallery had only three examples of his art. Like so many of his later works, *From Cows* illustrates Dove's intention not to describe the factual details of his subject but to evoke its presence by revealing the essence of its form. Weaving the greens of the background with the undulating brown shape of the cow, Dove created an image that speaks to the voluptuousness of nature in general rather than to any one specific object.

While many American artists of this century have sought their inspiration in the natural landscape, others have been fascinated with the new urban or industrial environment. Louis Lozowick's two lithographs *Corner of a Steel Plant*, 1929 and *Yellow Moon*, 1967 (cats. 74 and 86, see page 75), selected from seven works given by the artist's widow and son, Adele and Lee Lozowick, offer two quite different visions of this landscape. The earlier reflects the optimistic vision that many American artists had for technology in the 1920s. By simplifying the geometric forms of the steel plant and eliminating all distracting details, Lozowick celebrated the beauty and strength of the new technology and thus presented it as a positive and benevolent force in American life. *Yellow Moon* describes a scene more chaotic than the earlier image. It depicts a complicated grid of power lines dotted with electric insulators that glow with an eery yellow light. Complex and far less optimistic, it presents an ominous picture of American industry.

Mr. and Mrs. Irwin Millard Heine's gift of the ten volumes of *The Works of Charles Paul de Kock*, 1905–1907 (cat. 62, see page 77), with fourteen etched illustrations by John Sloan, enables us to add bound volumes to our collection of single-leaf

cat. 85. Harry Callahan, *Venice*

cat. 89. Harry Callahan, *Providence*

prints by this important American painter of the Ash Can School. Although Sloan's work is usually characterized by his study of American life, in these book illustrations, perhaps because of the nature of the text, he seems to have turned back to the French rococo period for his inspiration.

The Gallery's photography collection also saw significant additions in 1991. Most notably we received as gifts our first color photographic prints. Mr. and Mrs. David C. Ruttenberg gave the Gallery two dye transfer color prints by Harry Callahan, *Venice*, 1957 (cat. 85) and *Providence*, 1977 (cat. 89). Unlike many photographers of his generation who dismissed color photography as garish or amateurish, Callahan has consistently explored the potential of both black and white and color throughout his entire career. *Venice*, made the year Callahan was selected with Richard Diebenkorn to represent the United States in the Venice Biennale, demonstrates his remarkable ability to use both color and form to evoke a mood and express the surreal mystery of the ur-

ban environment. *Providence* is part of a series of studies Callahan made of homes in his Rhode Island neighborhood that had been recently and often lavishly repainted to hide their age and deterioration. Using a wide-angle lens to give the architecture a disjointed effect, the photographer clearly delighted in revealing these raucous harmonies. These color photographs, added to the black and white images purchased with funds from the Collector's Committee, including *Multiple Exposure Trees, Detroit*, 1942 (cat. 80), provide the Gallery with a solid foundation on which to build an important holding of Callahan's art.

In addition we received our first color photographs by Walker Evans, a gift from Mr. and Mrs. Harry H. Lunn, Jr. Although Evans is best remembered for his superb black and white photographs, many of which we presented in our 1991 exhibition *Walker Evans: Subway Photographs and other Recent Acquisitions*, he worked with color intermittently in the last twenty years of his life. *Trash* (cat. 88) from 1970 is an excellent example not

cat. 88. Walker Evans, *Trash*

only of Evans' continuing fascination with the debris of American society, but also his investigation of the ways in which color and texture could be used to intensify our appreciation of these mundane details of everyday life.

Continuing her unstinting generosity, Virginia Adams donated *Coast South of Saint Sebastian, Oregon*, 1968 (cat. 87) by her late husband Ansel Adams. Not only is this an extremely rare print, but its subject, the Pacific Ocean, is also, surprisingly, uncommon in Adams' work. Despite the fact that he was in many ways the epitome of a West

cat. 87. Ansel Adams, *Coast South of Saint Sebastian, Oregon*

cat. 80. Harry Callahan, *Multiple Exposure Trees, Detroit*

cat. 81. Ansel Adams, *Moro Rock, Sequoia National Park and Sierra Foothills*

cat. 67. Charles Burchfield, *Rail Fence*

Coast artist and lived his entire life first in San Francisco and later in Carmel, California, Adams made relatively few photographs of the ocean and coastline. Both this work, with its striking contrast between the scattered driftwood in the foreground and the dramatic rocks in the background, and *Moro Rock, Sequoia National Park and Sierra* *Foothills*, c. 1945 (cat. 81), a gift from Russ Anderson and Margaret W. Weston, with its bold formal elements and dramatic recesses of space, celebrate the strength and complexity of the natural landscape that fascinated Adams throughout his entire career.

cat. 79. Arthur Dove, *From Cows*

62
John Sloan
American, 1871–1951
"So you want some broomstick! Well you shall have it." 1905
etching, 214 x 135 (8 ⁷/₁₆ x 5 ³/₈)
illustration in Charles Paul de Kock's *Monsieur Cherami*, vol. 2 (New York, 1905)
Gift of Mr. and Mrs. Irwin Millard Heine, in Honor of the Fiftieth Anniversary of the National Gallery of Art

63
Emil Nolde
German, 1867–1956
Man with a Pipe (Self-Portrait), 1907
lithograph, 573 x 402 (22 ⁹/₁₆ x 15 ¹³/₁₆)
Ailsa Mellon Bruce Fund
See illustration on page 62.

64
Gwen John
British, 1876–1939
Self-Portrait, 1907–1909
black chalk, 270 x 221 (10 ⁵/₈ x 8 ¹¹/₁₆)
Gift of Mr. and Mrs. James T. Dyke, in Honor of the Fiftieth Anniversary of the National Gallery of Art
See illustration on page 62.

65
Ernst Ludwig Kirchner
German, 1880–1938
Windmill near Burg on Fehmarn, 1908
lithograph on japan paper, 402 x 476 (15 ⁷/₈ x 18 ³/₄)
Ruth and Jacob Kainen Collection, Gift in Honor of the Fiftieth Anniversary of the National Gallery of Art
See illustration on page 65.

66
Ernst Ludwig Kirchner
German, 1880–1938
Girls from Fehmarn, 1913
woodcut on yellow paper, 514 x 441 (20 ¹/₄ x 17 ³/₈)
Ruth and Jacob Kainen Collection, Gift in Honor of the Fiftieth Anniversary of the National Gallery of Art
See illustration on page 64.

67
Charles Burchfield
American, 1893–1967
Rail Fence, 1916
watercolor and graphite, 302 x 227 (11 ¹⁵/₁₆ x 8 ¹⁵/₁₆)
Gift of Ira Spanierman, in Honor of the Fiftieth Anniversary of the National Gallery of Art

cat. 75. Pablo Picasso,
Two Nudes Resting

cat. 78. Henri Matisse,
Reclining Nude

cat. 76. Pablo Picasso, *Sculptor at Rest before a Bacchanal with a Bull*

68
Ernst Ludwig Kirchner
German, 1880–1938
Fanny Wocke, 1916
woodcut on blotting paper, 305 x 400 (12 x 15 ¾)
Ruth and Jacob Kainen Collection, Gift in Honor of the
Fiftieth Anniversary of the National Gallery of Art

69
Ernst Ludwig Kirchner
German, 1880–1938
The Wife of Professor Goldstein, 1916
woodcut on blotting paper, 455 x 241
(17 ¹⁵⁄₁₆ x 9 ½)
Ruth and Jacob Kainen Collection, Gift in Honor of the
Fiftieth Anniversary of the National Gallery of Art
See illustration on page 8.

70
Sir Muirhead Bone
Scottish, 1876–1953
Calm on the Mediterranean, 1920–1930
watercolor, 252 x 354 (9 ¹⁵⁄₁₆ x 13 ¹⁵⁄₁₆)
Gift of Mortimer Brandt, in Honor of the Fiftieth
Anniversary of the National Gallery of Art

71
Ernst Ludwig Kirchner
German, 1880–1938
Portrait of a Girl (L's Daughter), 1921
lithograph on pink paper, 642 x 559 (24 ¼ x 22)
Ruth and Jacob Kainen Collection, Gift in Honor of the
Fiftieth Anniversary of the National Gallery of Art

72
Lovis Corinth
German, 1858–1925
Sigbert Marzynski, 1923
lithograph, 534 x 425 (21 x 16 ¾)
Gift of the Marcy Family in Memory of
Sigbert H. Marcy
See illustration on page 63.

73
Paul Klee
Swiss, 1879–1940
Old Man Reckoning, 1929
etching, 297 x 239 (11 ¹¹⁄₁₆ x 9 ⁷⁄₁₆)
Gift of Frank R. and Jeannette H. Eyerly, in Honor of
the Fiftieth Anniversary of the National Gallery of Art
See illustration on page 63.

cat. 70. Sir Muirhead Bone, *Calm on the Mediterranean*

74
Louis Lozowick
American, 1892–1973
Corner of a Steel Plant, 1929
lithograph, 288 x 200 (11 3/8 x 7 7/8)
Gift of Adele and Lee Lozowick, in Honor of the Fiftieth
Anniversary of the National Gallery of Art

75
Pablo Picasso
Spanish, 1881–1973
Two Nudes Resting, 1931
drypoint, 339 x 444 (13 3/8 x 17 1/2)
Gift of Lesley Ryan, in Honor of the Fiftieth
Anniversary of the National Gallery of Art

76
Pablo Picasso
Spanish, 1881–1973
Sculptor at Rest before a Bacchanal with a Bull, 1933
etching, 340 x 444 (13 3/8 x 17 1/2)
Gift of Lesley Ryan, in Honor of the Fiftieth
Anniversary of the National Gallery of Art

77

Henri Matisse

French, 1869–1954

Circe, 1935

soft-ground etching, 293 x 225 (11 ⁹⁄₁₆ x 8 ¾)

illustration in James Joyce's *Ulysses* (New York, 1935)

Gift of Mrs. H. Dunscombe Colt, in Honor of the
Fiftieth Anniversary of the National Gallery of Art

78

Henri Matisse

French, 1869–1954

Reclining Nude, 1935

graphite, 250 x 329 (9 ⅞ x 12 ¹⁵⁄₁₆)

Gift of Mr. and Mrs. Henry Brandon, in Honor of the
Fiftieth Anniversary of the National Gallery of Art

79

Arthur Dove

American, 1880–1946

From Cows, 1937

watercolor and pen and black ink, 127 x 177 (5 x 7)

Gift of Mr. and Mrs. William C. Janss, in Honor of the
Fiftieth Anniversary of the National Gallery of Art

80

Harry Callahan

American, born 1912

Multiple Exposure Trees, Detroit, c. 1942

gelatin silver print, 84 x 113 (3 ⁵⁄₁₆ x 4 ⁷⁄₁₆)

Gift of the Collectors Committee

See illustration on page 69.

cat. 74. Louis Lozowick, *Corner of a Steel Plant*

cat. 86. Louis Lozowick,
Yellow Moon

cat. 71. Ernst Ludwig Kirchner, *Portrait of a Girl (L's Daughter)*

81
Ansel Adams
American, 1902–1984
Moro Rock, Sequoia National Park and Sierra Foothills, c. 1945
gelatin silver print, printed 1970s
256 x 321 (9 7/8 x 12 5/8)
Gift of Russ Anderson and Margaret W. Weston, in Honor of the Fiftieth Anniversary of the National Gallery of Art
See illustration on page 69.

82
Milton Avery
American, 1885–1965
Birds and Sea, 1955
woodcut on japan paper, artist's proof in blue
306 x 679 (12 1/16 x 26 3/4)
Gift of the Avery Family, in Honor of the Fiftieth Anniversary of the National Gallery of Art
See illustration on page 60.

83
Milton Avery
American, 1885–1965
Birds and Sea, 1955
woodcut on japan paper, artist's proof in brown and black, 307 x 379 (12 x 29 ⅛)
Gift of the Avery Family, in Honor of the Fiftieth Anniversary of the National Gallery of Art
See illustration on page 60.

84
Milton Avery
American, 1885–1965
Birds and Sea, 1955
woodcut in black on japan paper
314 x 697 (12 ⅜ x 27 ⁷⁄₁₆)
Gift of the Avery Family, in Honor of the Fiftieth Anniversary of the National Gallery of Art
See illustration on page 60.

85
Harry Callahan
American, born 1912
Venice, 1957
dye transfer print, 224 x 341 (8 ⅞ x 13 ⁷⁄₁₆)
Gift of Mr. and Mrs. David C. Ruttenberg, Courtesy of The Ruttenberg Arts Foundation, in Honor of the Fiftieth Anniversary of the National Gallery of Art
See illustration on page 66.

cat. 77. Henri Matisse, *Circe*

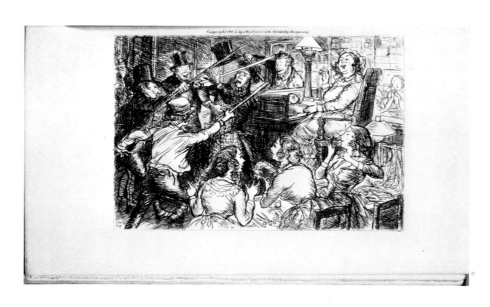

cat. 62. John Sloan, *"So you want some broomstick! Well you shall have it."*

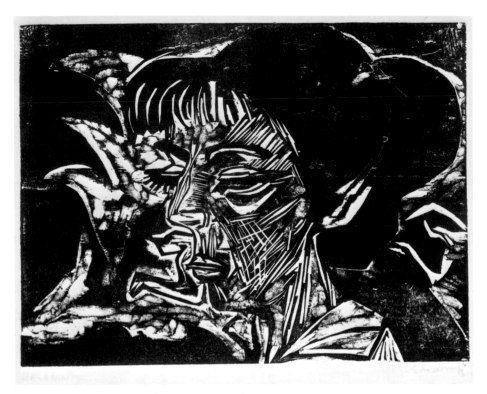

cat. 68. Ernst Ludwig Kirchner, *Fanny Wocke*

86
Louis Lozowick
American, 1892–1973
Yellow Moon, 1967
color lithograph, 157 x 362 (6 ³/₁₆ x 14 ¹/₄)
Gift of Adele and Lee Lozowick, in Honor of the Fiftieth
Anniversary of the National Gallery of Art

87
Ansel Adams
American, 1902–1984
Coast South of Saint Sebastian, Oregon, 1968
gelatin silver print, 639 x 626 (25 ³/₁₆ x 24 ⁵/₈)
Gift of Virginia Adams, in Honor of the Fiftieth
Anniversary of the National Gallery of Art
See illustration on page 68.

88
Walker Evans
American, 1903–1975
Trash, 1970
chromogenic print, 204 x 255 (8 x 10)
Gift of Mr. and Mrs. Harry H. Lunn, Jr., in Honor of
the Fiftieth Anniversary of the National Gallery of Art
See illustration on page 67.

89
Harry Callahan
American, born 1912
Providence, 1977
dye transfer print, 224 x 341 (8 ⁷/₈ x 13 ⁷/₁₆)
Gift of Mr. and Mrs. David C. Ruttenberg, Courtesy of
The Ruttenberg Arts Foundation, in Honor of the
Fiftieth Anniversary of the National Gallery of Art
See illustration on page 66.

The Contemporary Era

RUTH E. FINE

SINCE MARCH 1991 MORE THAN seven hundred contemporary drawings and prints, illustrated books, and portfolios have been donated to the National Gallery by private collectors, print publishing workshops, and artists. The most extensive group of drawings came as part of the world-renowned Dorothy and Herbert Vogel Collection, which comprises more than two thousand drawings, paintings, and sculptures by approximately two hundred artists. Selections from this extraordinary treasure are to be transferred to the Gallery over an extended period; 130 of the Vogels' drawings came to the Gallery in 1991. The focus of the Vogels' collection has been conceptual art and minimalist art, two major directions pursued by artists in recent decades. Already the Vogels' gift has transformed our contemporary drawings collection from a modest one to one of specific strengths.

Two of the Vogel drawings, collages by Christo and Robert Mangold, are included in this exhibition. Christo, best known for altering vast expanses of land by wrapping or otherwise calling attention to the landscape, has impelled us to question perceptions of our surroundings as well as our relationship to them. *Valley Curtain, Project for Rifle, Colorado,* 1971 (cat. 95), one of three drawings and two sculptures by Christo in the Vogel Collection and the first of his works to be acquired by the Gallery, is related to a project executed in the Rocky Mountains. It is an example of the studies and proposals Christo makes to raise funds for his monumental undertakings; in

these studies the artist presents us with his dreams even as he works out details of bringing them to reality.

The plan for *Valley Curtain* called for 250,000 square feet of synthetic fabric to span a valley 1,250 feet wide. Annotations on the Gallery's collage indicate Christo's concern with the concrete footings that were to hold the curtain in place. This necessity was short-lived. Twenty-eight months after the project's conception in 1970 and within two days of its completion, gale warnings led to its dismantling.

Thirty-nine drawings and paintings made by Robert Mangold between 1966 and 1987 are among the Gallery's 1991 Vogel Collection acquisitions. Together they offer a splendid overview of Mangold's long-standing exploration of shape-line and color-surface relationships. His is an art of great subtlety. Tactile elements such as delicate shifts across the field, or movement from vivid color to black, from paint to graphite, are of immense importance in his work. It was his practice in the Frame Paintings series to develop studies using cut-out pieces of paper; the collage *Four Color Frame Painting #1,* 1984 (cat. 109) preceded a work on canvas of the same title. The composition is also loosely related to several prints Mangold made during this period. The Vogels' gift of Mangold's drawings and paintings contains our first unique pieces by the artist, who was previously represented at the Gallery by a portfolio of twelve etchings titled *Pages,* 1989.

Two marvelous drawings from about 1965 by

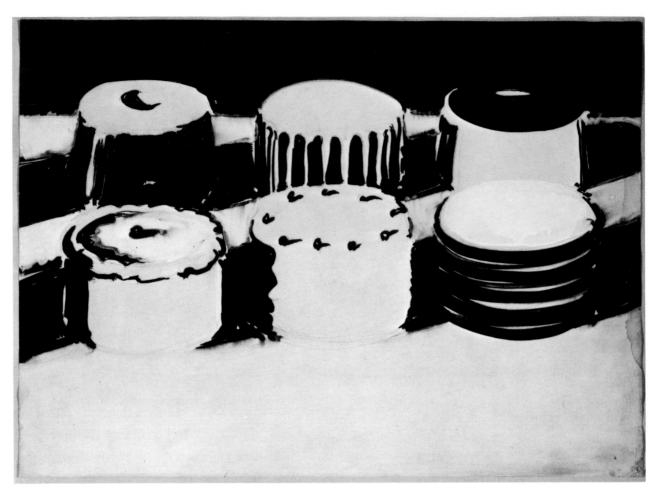

cat. 93. Wayne Thiebaud, *Study of Cakes*

artists working on opposite coasts of the United States confirm the pervasiveness of the pop art impulse during that period. Wayne Thiebaud in the San Francisco Bay area and James Rosenquist in New York were both exploring subjects from everyday life associated with that movement. Thiebaud's *Study of Cakes* (cat. 93), donated to the Gallery by the artist and his family, is the first of his drawings to enter our collection. Six distinct varieties of cakes are portrayed in this sheet, which is an especially pertinent subject for the National Gallery because of its close relationship to Thiebaud's sumptuous painting, *Cakes*, 1963, another fiftieth-anniversary gift from the Gallery's Collectors Committee (a support group formed to collect twentieth-century art), the 50th Anniversary Gift Committee, the Circle (a group of donors who have contributed to diverse acquisitions and educational programs), and the Abrams Family.

Study of Cakes is one of Thiebaud's more highly developed drawings of this subject for the period. It is important not only in that he used it as a source for depictions of cakes in other media, but also as it exemplifies his interest in foods associated with popular American culture—foods such as cakes, pies, ice cream cones—that are considered confections or delights, terms he has used as titles for his works. These subjects have served as a foil for Thiebaud's formalist bent, allowing him to explore composition, light, and structure, all apparent in the division of our drawing's surface into dramatic black and white areas. He calls our attention to the richness and variety of whites evident in the luminosity of his painterly white surfaces on the subtle cream paper.

Similar interest in everyday objects and con-

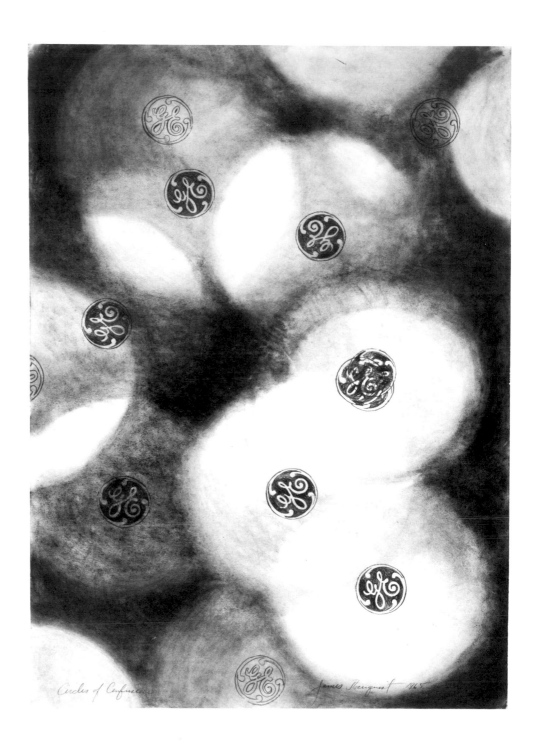

cat. 90.
James Rosenquist,
Circles of Confusion

sumer culture is expressed by James Rosenquist in his charcoal and graphite drawing *Circles of Confusion* (cat. 90), an array of light bulbs. As Rosenquist often does, he set his subject in a mysterious and somewhat disorienting context. The light bulb was featured in a number of his works during the mid-1960s, notably among the images in his famous and monumental 1965 painting, *F-111*. Rosenquist's light bulb has many implications outside his own iconography, however, including cartoonists' identification of a lit bulb with the emergence of an idea and the General Electric Co.

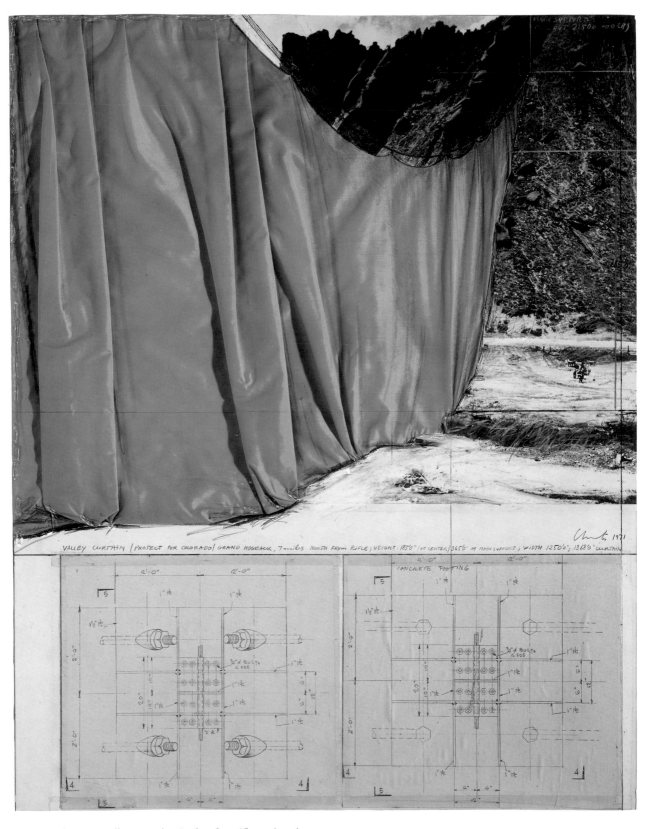

VALLEY CURTAIN (PROJECT FOR COLORADO) GRAND HOGBACK, 7 miles North from Rifle; HEIGHT: 185'6" / AT CENTER / 365'6" AT MAIN SUPPORT; WIDTH 1250'6"; 1368'0" CURTAIN

cat. 95. Christo, *Valley Curtain, Project for Rifle, Colorado*

cat. 109.
Robert Mangold,
*Four Color Frame
Painting #1*

logo as a manifestation of artists' growing interest in the interaction of art and technology. Implicit as well may be a satirical response to the threat of confusion caused by powerful corporate technologies. *Circles of Confusion*, the gift of Richard Feigen, is our first independent drawing by Rosenquist and an important addition to our representation of the art of the 1960s. Its size and high degree of finish make it an unusual work from this period of Rosenquist's career. In its muted tonalities it differs radically from his recent more highly colored drawings in the Gallery's collection, which are studies on Mylar for prints in the Graphicstudio Archive. This collection of 257 prints and many related drawings and proofs by more than

thirty artists was the subject of a major Gallery exhibition last year.

Several recent acquisitions of works by Robert Smithson reflect a very different direction from pop during the 1960s and 1970s: that of artists' interest in working in the landscape and outside of the gallery system. Of our first works by this seminal figure, two are on view: *Mud Flow (F-14)*, 1969 (cat. 94) and *Moodna Quadrants*, 1972 (cat. 97). *Mud Flow*, selected from four important Smithson drawings donated or promised by Werner H. and Sarah-Ann Kramarsky, is one of several the artist executed as part of a series that proposed large-scale pours and flows of materials over landscape terrain. Smithson associated earth

cat. 94. Robert Smithson, *Mud Flow (F-14)*

cat. 97. Robert Smithson, *Moodna Quadrants*

with the mind in the September 1968 *Artforum*: "One's mind and the earth are in a constant state of erosion, mental rivers wear away abstract banks, brain waves undermine cliffs of thought, ideas decompose into stones of unknowing, and conceptual crystallizations break apart into deposits of gritty reason." The second of Smithson's drawings on view is the more colorful *Moodna*

cat. 112. Lucian Freud, *Head and Shoulders of a Girl*

Quadrants, donated by the estate of Robert Smithson with two small graphite studies for the same subject. Exploring his ongoing interest in the interpenetration of land and water, these sheets relate to a plan for a project for the Moodna River and Creek at Storm King Art Center, Mountainville, New York, unrealized at the time of the artist's tragic death in an airplane crash in 1973.

The most recently made of our 1991 drawings acquisitions is Eric Fischl's untitled work of 1991 (cat. 114), a monumental charcoal composition of six figures donated by the artist and Mary Boone. Fischl derived his figures from a variety of photographs—some taken by himself, others found elsewhere—that he combined to portray a tense yet ambiguous human interaction. The aura of mystery is heightened by sexual overtones in the con-

flation of nude and clothed figures, their poses, and gestures that have quietly aggressive suggestiveness. Moreover, the frontality of figures or faces draws the viewer into the composition as an active participant, further exacerbating a sense of unease. Fischl's mastery of his medium calls into action the great subtlety of charcoal, juxtaposing gray tones of great delicacy or velvety richness with a dark and incisive yet softly flowing line. This is the first work by Fischl to enter our collection and is an important representation of the art of drawing in this final decade of the twentieth century.

Since the late 1950s it has been standard practice for painters and sculptors to make prints in professional workshops where they have access to skilled printers and other craftsmen. This is re-

cat. 92. Andy Warhol,
Jacqueline Kennedy I

flected in all of the contemporary prints on view in this exhibition. Earliest among them are *Circles of Confusion* by James Rosenquist (cat. 91) and *Jacqueline Kennedy I* by Andy Warhol (cat. 92). The two screen prints are part of Eleven Pop Artists, volume 1, the first of three portfolios published at the height of the pop art movement. The complete portfolio, the first of the three to come to the Gallery, was generously donated by Francine Schear Linde. The screen-print medium was particularly popular during the 1960s for its flat colors and hard edges that were part of artists' concerns with technology that eschewed the look of being hand made. Rosenquist's colorful print of electric light bulbs is unusually subtle in this respect, its soft quality paralleling that of our related

grisaille drawing of the same title; Warhol's image is a more fitting example. Jacqueline Kennedy is one of several famous beautiful women whom Warhol celebrated, one other being Marilyn Monroe. Both heroines are closely associated with tragic death, another subject preoccupying the artist. These figures took on iconic status in his oeuvre and thus in the art of the period.

Among the most important aspects of contemporary prints at the National Gallery are our archive collections. The largest of these collections is the Gemini G.E.L. Archive, founded in 1981 with gifts from Sidney B. Felsen and Stanley Grinstein, the workshop's owners. The archive has been enhanced by their further gifts and those from other donors and now numbers more than thirteen

cat. 91. James Rosenquist,
Circles of Confusion

hundred prints and edition sculptures. Many were seen in our 1984 Gemini exhibition and more recently in *Art for the Nation: Gifts in Honor of the 50th Anniversary of the National Gallery of Art*.

The Gemini owners' most recent gift includes more than 280 works by twenty-nine artists. Some of these are recent publications and others were completed years ago but had not until now entered the archive. In the latter category is Jasper Johns' lithograph "M," 1972 (cat. 96), one of eight subjects referred to as The Good Time Charley Series by Richard S. Field in his catalogue raisonné of Johns' prints of the 1970s. Incorporated in the print, a rethinking of a 1962 painting of the same title, is a photographic image of the earlier canvas, reinforcing references to the three-

dimensional objects attached to it; in the same vein the print's tan border suggests the painting's frame. The print is one of twenty-five works by Johns donated by Gemini last year. Other artists represented in large number in this extraordinary gift are Sam Francis, Robert Rauschenberg, Ellsworth Kelly, Roy Lichtenstein, and Frank Stella.

Especially important to this exhibition is our very first gift from another major print workshop, Crown Point Press in San Francisco, founded in 1962 by Kathan Brown. Crown Point Press has specialized in etching but in recent years the shop has also worked in woodcut, taking artists first to Japan and then to China where they worked with master printers in the two very different methods traditional in these countries. The works included

cat. 99. Howard Hodgkin, *Thinking Aloud in the Museum of Modern Art*

in this exhibition are selected from a much larger group given by the press, including a variety of working proofs and edition impressions of etchings and woodcuts by Richard Diebenkorn, William T. Wiley, Pat Steir, and Al Held.

Unique treasures from Crown Point Press are three working proofs for Diebenkorn's *Combination*, 1981 (cats. 100–102), which the artist altered by drawing and/or collage as he developed the image. He considerably modified the forms and made major shifts in color, converting the green field to a reddish one and in reverse changing a red tone in the spade form at the upper right to a green. The finished version of *Combination* (cat. 103) was a gift from Joshua P. Smith, who last year also donated several other prints and portfolios from Crown Point Press, among them our first works by Hans Haacke and Tom Marioni.

Like Diebenkorn, William T. Wiley made radical changes in developing *Now Who's Got the Blue Prints*, 1989 (cat. 111). In fact the image evolved

in several stages over a decade and was published under separate titles, the first of which was *Nowhere's That Blame Treaty*, 1979. *Now Who's Got the Blue Prints* is quintessential Wiley: an extraordinary layering of marks and images conflating highly personalized symbols with others that have more universal associations. References to the artist and his materials, music, stars, the sun, the moon, a skull, and architectural elements are all embedded in this masterful network of lines.

Pat Steir's *Rainclouds*, 1991 (cat. 113), printed from a wonderfully direct painting etched with acid onto a metal plate, is closely related to the waterfall images she has explored in recent years in prints, paintings, and drawings. Steir's fluid marks and gestures effusively add meaning to her watery subject. Printmaking has played an especially important role in her art for more than twenty years, and her affinity with her medium is as evident in small jewellike pieces such as *Rainclouds* as it is in her larger multicolor etchings and woodcuts, some of which are also included in the

cat. 110. Elizabeth Murray, *Untitled*, from *Her Story*

cat. 113. Pat Steir, *Rainclouds*

Crown Point Press gift. These are the Gallery's first works by Pat Steir.

Artist Sam Francis made a generous gift of fifty-five prints to the National Gallery last year. Particularly exciting is his untitled work of 1983 (cat. 106), our first of Francis' very beautiful monotypes. It is one of an important group of unique images printed from woodblocks at Experimental Workshop, San Francisco, in the early 1980s. Francis' strong colors and powerful forms were printed from multiple pieces of plywood, irregular in shape and size, that were laid onto a wooden base, and together they functioned as a matrix. In combination with areas of intense color, Francis used ghost images made from wood that had previously been printed in other works in the series; the thin film of ink that remained achieved gentle modulations of pale tone that heighten the wood grain. His loose painterly marks result from splattering color directly on his matrix as if on canvas. The balance of Francis' gift is a little-known series of self-portraits of penetrating intensity as well as

wonderful humor, printed in etching and lithography during the early 1970s.

Another generous artist-donor last year was June Wayne, the founder of Tamarind Lithography Workshop, which was active in Los Angeles from 1960 to 1970. In addition to facilitating the art of lithography for hundreds of others, Wayne also accomplished an impressive corpus of her own prints. This year she donated twenty-five of these dating from 1951 to 1987 to fill gaps in our collection. The collector Lloyd Rigler also contributed to this effort by giving a group of important prints and suites by Wayne including the portfolio Solar Flares, 1983, which exemplifies her interpretation of laws of nature and her interest in space exploration. Brilliantly colorful, *Solar Flames, Solar Burst, Solar Flash, Solar Wave* (cat. 108), and *Solar Refraction* are printed on paper bearing the artist's own watermark and enclosed in a Mylar wrapper that acts as title page and colophon.

In addition to her own art, June Wayne also

cat. 100. Richard Diebenkorn, *Combination* (working proof 1)

cat. 101. Richard Diebenkorn, *Combination* (working proof 4)

cat. 102. Richard Diebenkorn, *Combination* (working proof 10)

cat. 103. Richard Diebenkorn, *Combination*

gave a selection of more than fifty prints and portfolios by some thirty artists. Most are lithographs from Tamarind Institute in Albuquerque, the successor to the Tamarind Lithography Workshop. Included are our first works by Elaine de Kooning and Yvonne Jacquette. Jacquette's *Brooklyn Bridge Reflected, Night*, 1983 (cat. 107, see page 97) is a moody, dark scene punctuated by the glow of city lights, combining the density and liveliness of the urban environment with the romantic nature of

GEMINI III

cat. 96.
Jasper Johns, *"M"*

waterways. Jacquette infused the popular subject of the Brooklyn Bridge with her own highly personal style, taking advantage of the softness and gesture of crayon marks translated as lithography.

Mrs. Robert A. Hauslohner's extraordinary gift last year included more than 180 drawings and prints, illustrated books, and portfolios by dozens of artists. The focus of her gift is contemporary work, although several pieces date from the late nineteenth and earlier twentieth centuries. The collection reflects an eclectic taste and includes a unique impression of Stanley William Hayter's 1949 engraving *Tropic of Cancer*, Red Grooms' 1981 watercolor *Seated Woman*, and the marvelously subtle soft-ground etching by Howard Hodgkin, *Thinking Aloud in the Museum of Modern Art* of 1979 (cat. 99). Hodgkin's densely layered velvety sweeps of black ink on white paper, from

cat. 114. Eric Fischl, *Untitled*

cat. 105. Markus Lüpertz, untitled, from
Ich Stand vor der Mauer aus Glas

a series entitled In the Museum of Modern Art, suggest light and air within an architectural framework.

In recent years the Gallery's Collectors Committee has designated certain funds for the acquisition of works on paper. Among last year's purchases were our first prints by the British artists Tony Cragg and Lucian Freud. Freud's *Head and Shoulders of a Girl*, 1990 (cat. 112) portrays a closely observed figure whose inward gaze is as intense as the artist's gaze upon her. The model's rather commonplace pose is dramatized by its placement on the sheet, and the artist's consum-

mate handling of etching provides a vast array of markings to suggest the structure and surfaces of the figure, for example hair as differentiated from skin. Also from the Collectors Committee came two 1981 lithographs by Joan Mitchell including *Flower I* (cat. 104, see page 98) published by Tyler Graphics Ltd., another of this country's major workshops. The radiant color and vigorous gesture of Mitchell's strokes richly convey her heightened responses to the essence of landscape, achieving a suggestion of space as well as weight, air as well as solidity of form.

The Gallery also received wonderful illustrated

cat. 111. William T. Wiley, *Now Who's Got the Blue Prints*

books in the contemporary field last year. Jim Dine donated four books that include dozens of his etchings, among them the *Temple of Flora*, 1984, and *Glyptotek*, 1988. Included here is the earliest of the four, one that is less known than the others: *Mabel: A Story*, 1977 (cat. 98, see page 100), with twelve portrait etchings accompanying a text by Robert Creeley. Each portrait is distinguished by a different mood—anger, thoughtfulness, coyness—which Dine has communicated by emphasizing a particular aspect of the face. His facility in handling tools produces an amazingly diverse variety of marks and surfaces throughout

the volume, and unique to this copy is the hand-colored plate that suggests Dine's propensity for combining painting with printing.

Another unique volume is a special copy of Markus Lüpertz' *Ich Stand vor der Mauer aus Glas* (I Stood before the Glass Wall), 1982 (cat. 105), with a hand-painted page. The book is one of three publications with Lüpertz' text and illustrations published in conjunction with exhibitions during the 1980s; in each of them a few printed colors transport a protagonist through the sequence of pages, creating a sense of continuity while developing action over time. By this means

cat. 106. Sam Francis, untitled

cat. 108. June Wayne, *Solar Wave*

the artist has transformed a spare suggestion of a figure into one that is quite specific in character. Our first acquisitions by the artist, a complete set of the three books without hand-colored pages,

was donated last year by Brenda and Robert Edelson.

Another book, *Her Story*, 1988–1990 (cat. 110), a volume of Anne Waldman's poetry with images by Elizabeth Murray, is our first example of Murray's work. At this intimate scale she has incorporated the same sort of energy as well as many of the objects associated with her large, three-dimensional canvases—cups, books, chairs, traffic lights in warped perspectives, often altered to offset immediate recognition. Murray's fracturing and synthesizing are sympathetic to Waldman's poems: both author and artist invoke vignettes of personalized spaces and relationships as a means to interpret our modern world. *Her Story*, the gift of Paula Cooper Gallery, was published by Universal Limited Art Editions, the workshop that in 1957 helped set into motion the printmaking revival that transformed the art of the late twentieth century.

This exceedingly diverse group of gifts suggests the extraordinary range of responses that artists have had to the complexities of our time. For their imagination, intelligence, and talent we are grateful just as we are grateful to the many donors who have enabled us to add these exciting works to our collection.

90

James Rosenquist
American, born 1933
Circles of Confusion, 1965
charcoal and graphite, 1,048 x 752 (41 ¼ x 29 ⅝)
Gift of Richard L. Feigen, in Honor of the Fiftieth
Anniversary of the National Gallery of Art
See illustration on page 81.

91

James Rosenquist
American, born 1933
Circles of Confusion, 1965
color screenprint, 609 x 508 (24 x 20)
from the portfolio *11 Pop Artists*, published by Original
Editions
Gift of Francine Schear Linde, in Honor of the Fiftieth
Anniversary of the National Gallery of Art
See illustration on page 87.

92

Andy Warhol
American, 1928–1987
Jacqueline Kennedy I, 1965
screenprint in silver, 609 x 508 (24 x 20)
from the portfolio *11 Pop Artists*, published by Original
Editions
Gift of Francine Schear Linde, in Honor of the Fiftieth
Anniversary of the National Gallery of Art
See illustration on page 86.

93

Wayne Thiebaud
American, born 1920
Study of Cakes, c. 1965
ink and chinese white, 564 x 768 (22 ¼ x 30 ¼)
Gift of the Thiebaud Family, in Honor of the Fiftieth
Anniversary of the National Gallery of Art
See illustration on page 80.

94

Robert Smithson
American, 1938–1973
Mud Flow (F-14), 1969
graphite and felt-tip pen
452 x 609 (17 ¹³⁄₁₆ x 23 ¹⁵⁄₁₆)
Gift of Werner H. and Sarah-Ann Kramarsky, in Honor
of the Fiftieth Anniversary of the National Gallery
of Art
See illustration on page 84.

95

Christo
American, born Bulgaria 1935
Valley Curtain, Project for Rifle, Colorado, 1971
colored crayon and graphite on collage of photostat,
fabric, and blueprint, 711 x 559 (28 x 22)
The Dorothy and Herbert Vogel Collection,
Ailsa Mellon Bruce Fund, Patrons' Permanent Fund,
and Gift of Dorothy and Herbert Vogel
See illustration on page 82.

96

Jasper Johns
American, born 1930
''M,'' 1972
color lithograph, 975 x 743 (38 ½ x 29 ⅜)
published by Gemini G.E.L.
Gift of Gemini G.E.L.
See illustration on page 91.

97

Robert Smithson
American, 1938–1973
Moodna Quadrants, 1972
graphite and blue pencil, 479 x 608 (18 ⅞ x 23 ¹⁵⁄₁₆)
Gift of the Estate of Robert Smithson, in Honor of the
Fiftieth Anniversary of the National Gallery of Art
See illustration on page 84.

98

Jim Dine
American, born 1935
Mabel, 1977
etching with watercolor, 497 x 381 (19 ⁹⁄₁₆ x 15)
frontispiece to *Mabel: A Story*, poetry by Robert Creeley,
published by Editions de l'Atelier Crommelynck
Gift of Jim Dine, in Honor of the Fiftieth Anniversary of
the National Gallery of Art

99

Howard Hodgkin
British, born 1932
Thinking Aloud in the Museum of Modern Art, 1979
soft-ground etching on gray paper
767 x 1,013 (30 ⅛ x 40)
published by Petersburg Press
Gift of Mrs. Robert A. Hauslohner
See illustration on page 88.

cat. 107. Yvonne Jacquette, *Brooklyn Bridge Reflected, Night*

100
Richard Diebenkorn
American, born 1922
Combination (working proof 1), 1981
spitbite etching and aquatint with crayon
623 x 678 (24 ½ x 26 ¹¹/₁₆)
printed at Crown Point Press
Gift of Crown Point Press and the Artist, in Honor of
the Fiftieth Anniversary of the National Gallery of Art
See illustration on page 90.

101
Richard Diebenkorn
American, born 1922
Combination (working proof 4), 1981
color spitbite etching and aquatint with graphite and
collage, 780 x 549 (30 ¾ x 21 ⅝)
printed at Crown Point Press
Gift of Crown Point Press and the Artist, in Honor of
the Fiftieth Anniversary of the National Gallery of Art
See illustration on page 90.

102
Richard Diebenkorn
American, born 1922
Combination (working proof 10), 1981
color spitbite etching and aquatint with gouache
780 x 559 (30 ¾ x 22)
printed at Crown Point Press
Gift of Crown Point Press and the Artist, in Honor of
the Fiftieth Anniversary of the National Gallery of Art
See illustration on page 90.

103
Richard Diebenkorn
American, born 1922
Combination, 1981
color spitbite etching and aquatint
394 x 340 (15 ½ x 13 ⅜)
published by Crown Point Press
Gift of Joshua P. Smith, in Honor of the Fiftieth
Anniversary of the National Gallery of Art
See illustration on page 90.

cat. 104. Joan Mitchell, *Flower I*

104
Joan Mitchell
American, born 1926
Flower I, 1981
color lithograph, 1,083 x 830 (42 ⅞ x 32 ⅝)
published by Tyler Graphics Ltd.
Gift of the Collectors Committee

105
Markus Lüpertz
German, born 1941
untitled, 1982
color lithograph with gouache
420 x 295 (16 ⁹⁄₁₆ x 11 ⅝)
illustration in *Ich Stand vor der Mauer aus Glas*,
published by Galerie Rudolf Springer
Gift of the Collectors Committee
See illustration on page 93.

106
Sam Francis
American, born 1923
untitled, 1983
color woodcut monotype, 1,968 x 768 (77 ½ x 30 ¼)
published by Experimental Workshop
Gift of Sam Francis, in Honor of the Fiftieth
Anniversary of the National Gallery of Art
See illustration on page 95.

107
Yvonne Jacquette
American, born 1934
Brooklyn Bridge Reflected, Night, 1983
color lithograph, 483 x 638 (19 x 25 ⅛)
published by Tamarind Institute
Gift of June Wayne, in Honor of the Fiftieth
Anniversary of the National Gallery of Art

108
June Wayne
American, born 1918
Solar Wave, 1983
color lithograph, 439 x 435 (17 ⁵⁄₁₆ x 17 ⅛)
from the portfolio *Solar Flares*
Gift of Lloyd Rigler, in Honor of the Fiftieth
Anniversary of the National Gallery of Art
See illustration on page 95.

109
Robert Mangold
American, born 1937
Four Color Frame Painting #1, 1984
acrylic and graphite on four sheets of paper
471 x 444 (8 ⁹⁄₁₆ x 17 ½)
The Dorothy and Herbert Vogel Collection,
Ailsa Mellon Bruce Fund, Patrons' Permanent Fund,
and Gift of Dorothy and Herbert Vogel
See illustration on page 83.

110
Elizabeth Murray
American, born 1940
Untitled, 1988–1990
color lithograph with etching on chine collé
292 x 438 (11 ½ x 17 ¼)
illustration in *Her Story*, poetry by Anne Waldman,
published by Universal Limited Art Editions, Inc.
Gift of Paula Cooper Gallery, in Honor of the Fiftieth
Anniversary of the National Gallery of Art
See illustration on page 89.

111
William T. Wiley
American, born 1937
Now Who's Got the Blue Prints, 1989
color aquatint and soft-ground etching with burnishing
and drypoint, 1,321 x 1,035 (52 ¹⁄₁₆ x 40 ¾)
published by Crown Point Press
Gift of Crown Point Press and the Artist, in Honor of
the Fiftieth Anniversary of the National Gallery of Art
See illustration on page 94.

112
Lucian Freud
British, born 1922
Head and Shoulders of a Girl, 1990
etching, 690 x 544 (27 ⅛ x 21 ⁷⁄₁₆)
published by Brooke Alexander, Inc. and James
Kirkman Ltd.
Gift of the Collectors Committee
See illustration on page 85.

113
Pat Steir
American, born 1940
Rainclouds, 1991
color spitbite, soapground, and soft-ground aquatint
etching with drypoint in blue-green
248 x 316 (9 ¾ x 12 ⅜)
published by Crown Point Press
Gift of Crown Point Press and the Artist, in Honor of
the Fiftieth Anniversary of the National Gallery of Art
See illustration on page 89.

114
Eric Fischl
American, born 1948
Untitled, 1991
charcoal, 1,880 x 1,625 (74 x 60)
Gift of Eric Fischl and Mary Boone, in Honor of the
Fiftieth Anniversary of the National Gallery of Art
See illustration on page 92.

47/60

cat. 98. Jim Dine, *Mabel*